So many of us hunger for Antarctica. For its promise of something so notably new to our experience, pristine. Though very little is wholly pristine on this planet, very little is free of our "fantastic, greasy hope." It seems fitting that in her deep and thoughtful journey to the site of so many voyagers' ambitions Elizabeth Bradfield would turn to the form Bashō found so useful for his own *Narrow Road to the Interior*. A naturalist, poet, and photographer, Bradfield is as keen-eyed about the continent and its surrounding islands as she is about the souls counted present on the ship that takes them there. This balance between expansive views and focused clarity makes reading *Toward Antarctica* almost as good as sailing there ourselves.

—CAMILLE T. DUNGY, author of *Trophic Cascade* and editor of *Black Nature: Four Centuries of African American Nature Poetry*

Modern expedition ships sail south to Antarctica every year, carrying continent-baggers and bucket-listers who drink a toast to Shackleton, pat themselves on the back, and heroically claim, "We made it!" It takes a poet, and a darn good one, "to at once be there and to not even come close." This is Elizabeth Bradfield writing to the truth in what she calls, "crepuscular moments of poetry . . . Here on this unbridled ocean. Here on this world unto itself." Having been to Antarctica many times and studied its literature, I found this book an artful standout from the crowd, one garnished with reflection and rust, humor and humility, sincerity, and respect.

—KIM HEACOX, author of *Antarctica: The Last Continent, Jimmy Bluefeather*, and *The Only Kayak*

Reading Elizabeth Bradfield's *Toward Antarctica* is like having a poet's behind-the-scenes tour of a natural history museum. Through her expert eyes, the exquisite landscape and wildlife come into vivid view; so does the gutsy work and responsibility of being a naturalist guide. Inspired by the Japanese *haibun* form, the book pairs the lyric intensity of poetry with the fragmented, staccato prose of a mind trying to keep track of the flood of experience. Bradfield's gorgeous photographs add yet another dimension of aesthetic experience. Her work is a resonant exploration of bringing art and science together to sing a mindful duet.

—ALISON HAWTHORNE DEMING, author of *Zoologies: On Animals and the Human Spirit* and *Stairway to Heaven*; Chair of Environment and Social Justice at the University of Arizona, founder of the Field Studies in Writing Program

I enjoyed Elizabeth Bradfield's words and images from the Big White. Hers is an unusual approach, and one that is to be welcomed in the still small canon of artistic responses to the Antarctic—particularly by women. I wholeheartedly recommend this special book.

—SARA WHEELER, author of *Terra Incognita* and *The Magnetic North*

*Toward Antarctica* is a travelogue, a meditation, a photo-essay, a documentary poem, an ode, and an elegy. It is a work of eco- and cultural criticism, personal essay, history, and photojournalism. Like the poem-prose hybrid *haibun* form, which provides the structural basis for this book, *Toward Antarctica* moves between different genres and literary forms, challenging our notion of what a travel narrative can and should be. The best writers understand that all works of literature are hybrids at heart, and Elizabeth Bradfield pushes the limits of what we imagine poetry can do, capturing her time in Antarctica in lush yet always tightly controlled images that throb with musical life. With a photographer's eye and a naturalist's sense of the world, Bradfield shows us life in Antarctica to be a strange, magical, occasionally lethal mixture of the human and the animal, a place that exists as much in our romantic imaginations as it does in the world itself, an environment that continues to evade our comprehension even as it remains subject to our human impact. Bradfield's epic poem-memoir shows us that Antarctica is the continent to which we are ever traveling, upon whose shores we never truly arrive.

—PAISLEY REKDAL, author of *Imaginary Vessels* and *Intimate: An American Family Photo Album*

*Toward Antarctica* is the most original piece of travel writing about the Antarctic region I have read in years, combining the emotional honesty, immediacy, and telegraphic brevity of the diary with the literary control and imagistic precision of a fine poet. Through both her photographs and her writing, Bradfield challenges the clichés of the conventional Antarctic journey narrative while conveying a profound appreciation of the region's natural environment and human history. Well-informed but uninterested in asserting priority or authority, lyrical but never overblown, Bradfield is a literary tour guide in the best sense.

—ELIZABETH LEANE, Antarctic scholar and literary critic, author of *Antarctica in Fiction: Imaginative Narratives of the Far South*

# TOWARD ANTARCTICA

Elizabeth Bradfield

Book layout by Ann Basu

Library of Congress Cataloging-in-Publication Data
Names: Bradfield, Elizabeth, author.
Title: Toward Antarctica / Elizabeth Bradfield.
Description: First edition. | [Pasadena, California] : Boreal Books, an
imprint of Red Hen Press, [2018]
Identifiers: LCCN 2018046074| ISBN 9781597098861 | ISBN 1597098868
Subjects: LCSH: Bradfield, Elizabeth—Travel—Antarctica. |
Antarctica—Description and travel. | Naturalists—United States—Biography.
Classification: LCC G875.B73 A3 2019 | DDC 919.8904092 [B]—dc23
LC record available at https://lccn.loc.gov/2018046074

The National Endowment for the Arts, the Los Angeles County Arts Commission, the Ahmanson Foundation, the Dwight Stuart Youth Fund, the Max Factor Family Foundation, the Pasadena Tournament of Roses Foundation, the Pasadena Arts & Culture Commission and the City of Pasadena Cultural Affairs Division, the City of Los Angeles Department of Cultural Affairs, the Audrey & Sydney Irmas Charitable Foundation, the Kinder Morgan Foundation, the Meta & George Rosenberg Foundation, the Allergan Foundation, and the Riordan Foundation partially support Red Hen Press.

First Edition
Published by Boreal Books
an imprint of Red Hen Press
www.borealbooks.org
www.redhen.org

*For all my shipmates:*
*Fair winds and following seas.*

# CONTENTS

## III. The Peninsula, Etc. (There & Back, There & Back: Repeat)

## IV. HEADING HOME

# TOWARD ANTARCTICA

# PREFACE

*Toward Antarctica* is a record and exploration of my experience working as a naturalist in Antarctica, a place that had been an obsession from the time I discovered Alfred Lansing's *Endurance* at a used book store in 1997.

Since 2004, I have worked as a naturalist on ecotourism expedition ships—ships with 120 or fewer passengers upon which the primary objective is to experience a wild place through on-site explorations facilitated by a team of experts in various fields: botany, geology, history, ornithology, marine biology, and the like. In the past, this has been my main occupation; more recently I have balanced "ship work" with teaching. Traveling with others for weeks at a time aboard a ship, working as part of a team to help connect people to ecological and cultural subtleties of a place, feeds me profoundly as a poet and a citizen of the world. I am grateful to have found my way to this work, even with all the complications it can embody.

Until my first contract working in Antarctica, however, I had not been able to write while working as a naturalist. The two modes of thinking, observing, and connecting were at odds with each other. In "naturalist mode," I was too busy being present and answering questions and keeping to schedule. I could not drift and look inward in the way that writing poems requires. But working in Antarctica felt different. In part, it was because the longer voyages and days at sea allowed for a bit more down time. In part, it was due to the place itself. I knew my voyage would be an opportunity to ground-truth what I'd written in my 2010 collection of poems, *Approaching Ice*, which investigates "golden age" explorers like Shackleton and Scott as well as the contemporary lure of the high latitudes.

But how to open myself to writing and remain present in the manner that my job required? Having begun a study of *haibun* before joining the ship, I thought this form could help. In 1682, the renowned poet Matsuo Bashō started journeying by foot into remote areas of Japan for months at a time. Along the way, he wrote, and in trying to depict what such a journey meant on both a practical and an emotional level, he invented the *haibun* form.

In *haibun*, jotted diary-like prose is interspersed with and interrupted by short poems, usually haiku. As the Poetry Foundation says, these two modes allow a writer to explore "the external images observed en route, and the internal images that move through the traveler's mind during the journey."

As with much classical Japanese poetry and art, Bashō's work is infused with allusions to poets, stories, figures, and tropes that add resonance to his writing and which his contemporaries would have recognized. Given our diverse contemporary world, I have used footnotes here to offer readers access to that undercurrent in my own work.

Bashō's collections of travel-inspired *haibun* are interspersed with calligraphic paintings, and the dynamic between image, prose, and poem create a deeper, more mysterious rendering of his experience. I took the photographs included in this book as I usually do when working: as documentation, with an eye toward use in illustrated lectures. Upon returning home, though, I realized that some of them revealed something else. Something emotional. A visual counterbalance to the classic, heroic images we often see of that kept-wild place. On my second contract working in Antarctica, I went south with the intention of returning with more and better images. Truthfully, I'm not sure that second, more deliberate effort is better; I only ended up using fourteen of those photos. The majority of the

images here are from the time before I knew I'd need them, the time before I was looking with self-awareness.

Photography has an important history in Antarctica. For Shackleton and his cohort, the images they brought home to be printed or used as lantern slides were what paid off the voyage and hopefully rebuilt coffers for the next venture. I am not sure if the images in *Toward Antarctica* are looking back or forward. Ultimately both, I think.

Every year, thousands of tourists visit Antarctica. In the 2016–2017 season, IATTO (the International Association of Antarctic Tour Operators) reports that the total number was 44,367, an increase of 15% over the previous season. I understand the desire to travel there, the panic over getting there before it's "gone." I also don't know if I'll return.

As of this time, I have worked only twice in Antarctica, over the 2011–2012 and 2016–2017 seasons. The pages here draw from both periods. I consider my lack of extensive experience to be one of the strengths of this book. It demands a reckoning with what it means to travel to and through a dreamed-of place. It queries what it means to travel as an "expert" when one is at once that and also something . . . other. A seeker, let's call it.

Yes, I had knowledge of seals and whales and birds and oceans and the world of being a naturalist guide, but my time working in Antarctica is much more limited than many others'. And I am interested in the early confusion that occurs when a dreamed-of place becomes overwritten with tasks and routines—when *work* and all its systems, dynamics, economics, and complications come into play.

Although drawn from personal experience, I would not call *Toward Antarctica* nonfiction or memoir. It lives in the crepuscular world of poetry, sometimes exact and sometimes bent in order to better reflect one particular facet of the truth. I have deliberately kept the ship's name and those of my teammates obscured so that I could freely explore some of the less polished moments of my time and because I know this could be almost any ship, any crew.

I am grateful for the help of writers, artists, and interested readers in shaping this work. Particular thanks go to Gabriel Fried, for telling me it could be more when it was very young; Lisa Sette, for terrifying me with the thought it could be more then wrangling with me to get it right; Sean Hill for first introducing me to the *haibun* form; Peggy Shumaker and Boreal Books for believing it deserved a home. Lynn Brown, Christine Byl, Antonia Contro, Anne Haven McDonnell, Kim Heacox, Sean Hill, Veronica Maughan, Jody Melander, Jennifer Moller, Debbie Nadolney, Nancy Pearson, Janice Redman, Eva Saulitis, Ron Spatz, Alexandra Teague, Gabriel Travis, and Sarah Van Sanden—thank you for your readings, viewings, critiques, prods, and encouragement.

Thanks to *About Place, Alaska Quarterly Review, Barrow Street, Bat City Review, Copper Nickel, EarthDesk, Field, Fourth River, Kenyon Review, Orion Magazine's Blog, Poetry Northwest, Talking River, The Rumpus, Terrain. org, White Whale Review,* and The Academy of American Poets *Poem-a-Day* for publishing sections of this collection, sometimes in earlier versions. "Epilogue: A Letter Home" was originally published as one of *Terrain.org*'s "Letter to America" series. My deep thanks to Simmons Bunting for his editorial eye.

To those I have sailed with: thank you for all you've done to teach me and to help me teach others. Thank you for jokes, irreverence, on-water engine repair tips, words of warning, moral support, loaner gear, and serious engagement with how to open a place to being seen. Thank you for being there with me in Antarctica, particularly Kara, Danae, Luke, Michaela, Nicki, Peter, and Shoshanna and all those I worked with aboard the unnamed ship that could be any ship and yet was ours.

For my parents, who were there when I got the news that I would go South and witnessed me launch into an unmannerly excitement and did not make me feel ashamed. For Lisa, who went there first and yet who saw different things and brought back different news and to whom I am always grateful to return. And for Eva Saulitis—with hope that water connects us even now.

# Upon

Lurch upon the offer: Antarctic work

Upon paperwork & mandatory physical: resignation

Months imagining myself upon that ocean (worry worry worry worry
    wind, worry ice, worry stern landings in swell)

Guffaw upon being told to bring dresses & heels      Shopped & packed

Upon the ship     New crew & protocols

Upon Punta Arenas rubbed the Fuegian's bronze toe (charm for return
    before I set foot)     It was shined with fantastic, greasy hope

Upon Ushuaia    Upon the Falklands    Upon South Georgia where
    it began to feel close     Storied by elephants & kings

Calm seas upon each Drake crossing     Each of ten

Upon sea ice: fear     Would it break to brash?     Walked out
    Pretended comfort     Did not get dropped into the Weddell Sea

Upon the shore

Upon the Peninsula

Upon Adélie, leopard seal, emperor, snow petrel, crabeater, shag
    Juggle & jumble of facts

I put tongue to ice, smelled rookeries, was scoured

I have been there

I have not even come close

Peninsula, eyelash of a continent, you wink in collusion

---

A "stern landing" is when, just before hitting shore, the driver spins the Zodiac 180°, raises the engine, and puts the stern ashore first, rather than the bow. It's a tricky operation that, if the waves are ill-timed, can go horribly wrong. In Punta Arenas, there is a statue of Ferdinand Magellan in the main square. At his feet are a mermaid and two bronze "Fuegians," the indigenous people of Tierra del Fuego. One of them is Califate, whose foot dangles down the pedestal. If you rub the toe, the story goes, you will return to Punta Arenas from your venture to Antarctica. "Elephants and kings" refer to southern elephant seals and king penguins, both of which reign on South Georgia Island.

# I.

# Down the Coast
# (Getting There)

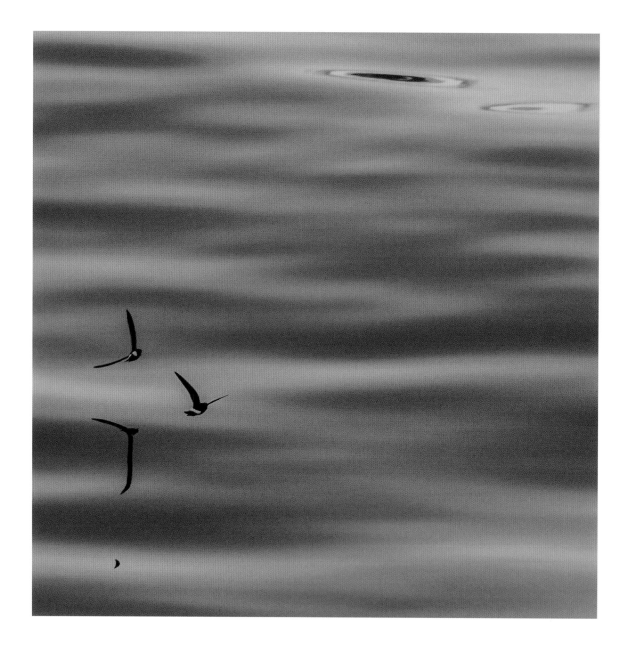

## Santiago, Valparaíso

Arrival after departure & arrival departure arrival . . . stutter toward start. Chilean customs near disaster (no US cash for entry, credit card denied, pesos exchanged back for tender they'd take—thankfully enough despite transactional loss). Then through. Meet B. Eight weeks ahead on the not-yet-met ship. Sniff each other's stories. Have you    ? Never. How about    ? Ever work with    ? Once, twice, maybe. In    ? For years. Deflect. Rankle. Smile. In the sussing, curiosity's sharp edge cuts toward status. What we both want to know: Are you ally or burden? Newbie or old hand? Teammate or diva? Are you good? Can you drive? Ever ripped a pontoon? Sheared a skeg? Flipped? Been fog-lost? Can you drive?

At last all crew landed, gathered, bussed west to Valparaíso for pre-ship overnight. Dropped off. Checked in. Hunker restless in room despite sun, city, light. Sleep hungry in travel's fugue.

<div style="text-align:center">

somewhere Neruda
watched over this *vast, irate sea*
rendering its light

</div>

---

The poet Pablo Neruda's late-in-life home, La Sebastiana, sits on Mount Florida, one of the high hills of Valparíso. Italicized words from "Ode to Valparíso" (trans. Margaret Sayers Peden).

# SIGNING ON AGAIN

Down crew-only stairs—paint-chipped rail, hand-grimed bulkheads, watertight door's caution-striped sill—to crew mess. Sit at sticky, vinyl tablecloth (deep bluewater) before ship's registry (a white craft afloat). Sign in, sign on: name, address, emergency contact, bank details. Instructions slurried through Finance's Greek & Safety's Bulgarian accents. Nod *understood, understood* when sentences end in crest. Get lifejacket with green laminated card carabinered to chest, billet number on front. All expedition staff P-something. This time: Papa Nine Three.

a memory:
ship aground, ebbing tide
dark, cold lapping sea

Submit certificates vouching competence: medical, crowd management, Zodiac operations . . . Paper to normalize and make of any possible disaster indemnified routine.

---

Some ship officers, like the Security Officer, just go by their title (Captain, Chief, Safety, Finance) as in "ask Security."

# Along the Coast

Niebla (bus count), Valdivia (radio check, bus count). Pisco sours at the German Club (departure bus count wrong, figure the missing walked back, luckily all accounted by all aboard). Puerto Montt to Osorno's fog-snagging, stark scree cone (dormant).

rabbled volcano
rough basalt shelters a blossom:
one tiger-orange bee

Switchback back (bus count doubted, recounted, ok). A relief that local guides spiel it, not me. I know mountains, evergreens, raptors but not Darwin's sightlines, *Nothofagus* soared by chimangos, what stories weave what threads to pull in telling. Aboard, learn uniform, routine, protocol, crew mess tactics. Settle on who to shadow. Certain courtesies prove universal: help buckle lifejackets, offer binoculars, point toward any sighted thing, boost any upwelling of wonder or delight.

---

Many note Osorno's similarity to Mt. Fuji. The name of Mt. Fuji's goddess, Konohanasakuya-hime, means "causing the blossom to bloom brightly." Charles Darwin saw Osorno, one of the most active volcanos in the Chilean Andes, erupt in 1835 during his second voyage on the HMS *Beagle*. *Nothofagus* is a mostly-evergreen genus of trees and shrubs native to the Southern Pacific edges; chimangos are a type of falcon.

# In the Fjords, Isla de Chiloé (First Penguins)

We chug south. Fjord by fjord. In each arm, pen after pen of salmon, a species twice wrong-hemisphered (south, west). Wrong-oceaned. The bus guides all *pro* so I swallow Alaska-learned outsider *con* despite despite despite ecology, disease, drugs, escapage. Black nets, orange-buoyed & round as the Hockney-blue zoo pool in Seattle where, age *child*, innocent, I must have first seen penguins.

<div style="text-align:center">

punctuating all
low-floating birds hunch, plunge
into deep-pressed flight

</div>

Channel & voyage now with new (new with) clarifying wildness. Past and present birds both small. The same? These: Humboldt. Name a glad link to rich south-sweeping current, large squid, down-gazing orange lily, cactus & skunk & pot-rich California county & a moon's sea—to the man who traveled with and brought back not arrogance but awe.

---

"Nature must be experienced through feeling" is one of the quotes taken from and touted of Alexander von Humboldt, who traveled through North and South America and wrote compellingly and generously about his experiences.

# Patagonia: Pio XI Glacier

But now. At last. At tiller. This throttle's particulars (stiff arm, ragged idle) acquired. Finally of use in a way I want to be used & useful. Overtowered by ice rivering to tidewater. The usual dangers, less known here: depth at face, advance, tongue? Gauge best as possible. Known cool of ice-breath. Known furl of wake. So used to retreat & loss beyond seasonal ablation, almost terrifying to see the hunger of advance . . .

<div align="center">

familiar ice

unfamiliar surge—forested edge

overcome

</div>

Steer to pace fact & awe, motion & drift. Putter in sun. Kelp geese strut the intertidal. Usual metaphors for blue fumbled as ice pops and groans. Glad to fumble them anew.

---

Glaciers can surge (rapidly advance) for any number of reasons. Often, this does not mean that the mass of the glacier itself is growing. Rather, some combination of factors causes the toe of the glacier to slide forward, pulling the whole pile of ice forward with it and thus thinning the glacier. In some cases, a surging glacier can move forward with startling rapidity. The Black Rapids Glacier of central Alaska "galloped" forward at a rate of 61 meters per day in 1936.

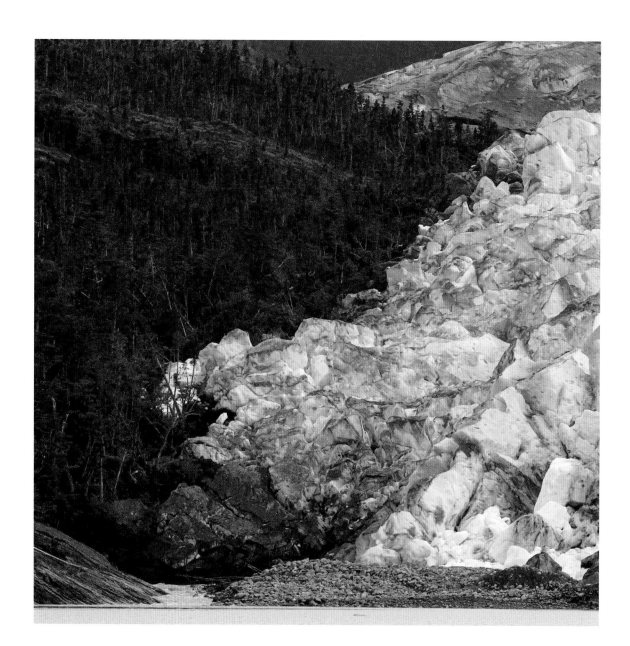

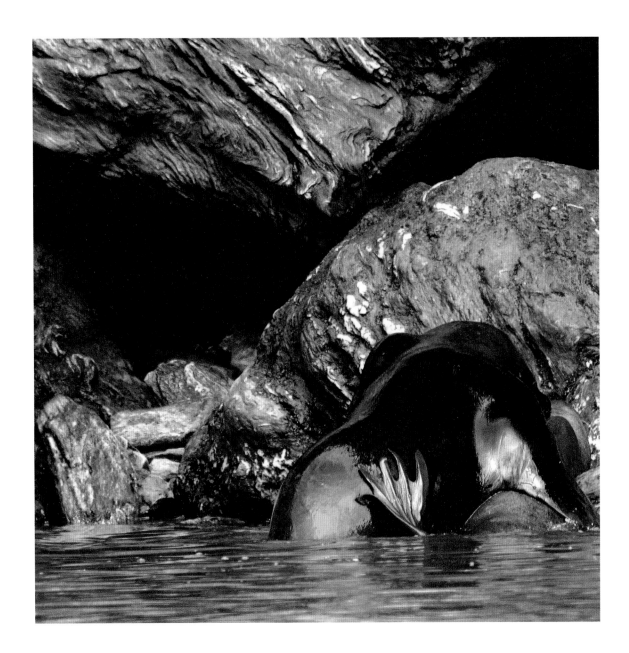

## STRAITS OF MAGELLAN

In strange channels, inside the entrance, snowed peaks across the mouth. Now water enlivened by whales. Hard to gauge size. Minkes? Orca? Are Bryde's whales here? Speak out quick-eager, wrong. L resists the throat jump of first and is right: sei.

> rostrum pillowing silk water before
> broken in arch, dive

Seis. Rare at home but seen two months ago, end of season, off Stellwagen, mind deep in the straddle of now and next, prepping for this water (then future). Startled thrum of *different*: shark-pocked flanks, quick pop of dorsal fin. A shine to them.

This will be the biggest group of whales I'll get all season. Ten sei whales.

> breath held, expelled
> they rise we surge toward looking
> toward what can't yet be seen

---

Stellwagen Bank is a shallow underwater plateau just north and west of Cape Cod. Sei whales often have small, circular divots on their skin from healed-over bites of cookie-cutter sharks. In May of 2015, 337 sei whales washed up on remote beaches in Patagonia between the Gulf of Penas and Pio XI glacier. Biologists suspected toxic algae which bloomed in above-average sea temperatures to be the culprit.

# GARIBALDI GLACIER

Ugly. Snout-stove, shove-nosed, South American sea lions. Tomorrow: Ushuaia. Today, in the land of fire, again glacial ice (usual geese, raptors, shags—see Pio XI—see how already jaded how easy to assume *usual*). But this. Their heat. Small cove. He chuffs toward her. Humped mounting against slick rock. Pink mouths open, chins lifted. Roll. Roil. Then *What?* Never. Radio-crackle. *Here.* Twice, his snout under her short tail. Twice his breath huffed to spray. Do guests turn away? No idea. I can't. His snout. Tomorrow (ashore, off duty, WiFi café) I will see your face.

> Zodiacs drift, bump
> we crane, ignore sought ice
> sea a slipping sheet

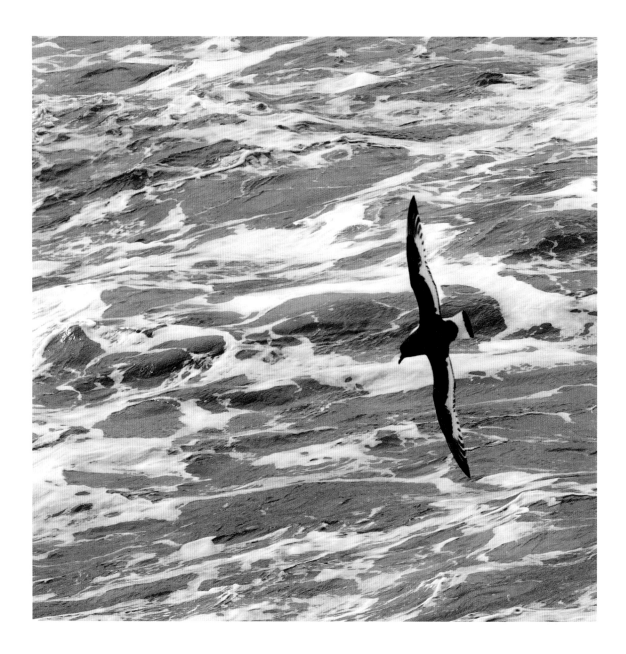

## ACROSS THE DRAKE, FORWARD CABIN

not affixed     bunk lifts

    slides          hits bulkhead

I lift        drop to mattress

    hull-shudder        wave-slosh

       we pound south

# II.

## SOUTH GEORGIA
## (MORE THERE THAN THERE)

# Mandatory Purification Rituals

Can't just *go*. Can't, more to the point, just *arrive, land*. You must prepare yourself. Before horizon is broken, we set up: housekeeping vacuums borrowed, disinfectant bright green in bins. Guests are called by deck. It takes an afternoon. They hand over anything wind might touch or that might touch what we'll call *earth*. They joke, we joke. Scrub & hose. *What cabin?* Butter knife in boot treads. It's hot, loud. We get punchy. J finds a seed in velcro, plucks it out. Shouts *One saved albatross!* Parka, pack, gloves, hat, walking stick. Ten coats later another grass seed—*One saved albatross!* Each pocket sucked by the vacuum wand. *You're fine. You're good. You're good. All clear.* They sign a document. I grumble at the beat-up, gritty pack of the guy about to "get" his last continent. B, who's served on committees, adds this: naturalists are the worst. All those hills hunkered, too broke or sappy to upgrade gear.

months, years preparing
dirty scamming tagalong
I am not prepared

IAATO (International Association of Antarctica Tour Operators) regulations require that visitors to Antarctica clean their gear before setting foot ashore—visitors to South Georgia are required to do the same (and if you go to both, clean between). Invasive species, particularly grasses, are a concern. As the climate warms, the concerns warm.

## Salisbury Plain

Distant surf. Distant fur seal shore-bustle. Silence of known but unseen distances in the cragged, unoccupied interior. Wind through tussac and rising up rising up calls (like washrags swept across window screens) of penguins. One king stands over another laid flat, lifeless but somehow less than dead because sockets eye-occupied, unemptied by skua plunge. Still attended by another (male, female no dimorphism allows that marker). And I—voyeur, witness—also attend.

> body, beak, feet, splayed
> slow perishing toward slow soil
> what grows from absence?

The standing king cries. To beckon? Ward off? Others move in, heads low, move off. Jab & nod. Jab & nod. No idea how long this will continue. No idea what the dead one died of. Get group A back to ship (deploy art of unpushy herding though most, grown chilled, have left already) after the allotted time (one hour). Next round beach-stationed, so no follow-up. I won't return again this season.

## Stromness

How many whales hauled here to render? Twenty years of whales. And yet air's empty of that smell. Climb the penguins' nest-ridge and find it lunar. Craters of empty nests, orbit of skua-cracked shells. A few gentoos still hunker eggs or chicks, bray to the hills. Where? What? Loss. (Is there a telling others use to make this not yet another grim tale? Subvert my new supposition, reroute me from woe.) Scat & tracks tell the story: reindeer walk through. Gentoos waddle-start. Skuas—winged wolves—swoop, steal, feast. No doubt now about harm.

unhatched shell cracked, extracted
more empty cupped in upturned palm

South Georgia's whalers processed 175,250 whales. Native birds, like gentoo penguins, are threatened by the reindeer because when the reindeer wander by, they startle penguins off their nests, leaving eggs and chicks unprotected and thus vulnerable. South polar skuas are intense avian predators in the gull family that behave a bit like a cross between a raven and a falcon. Reindeer were brought from the north by whalers to South Georgia for their meat (and possibly for territorial claim by Norway).

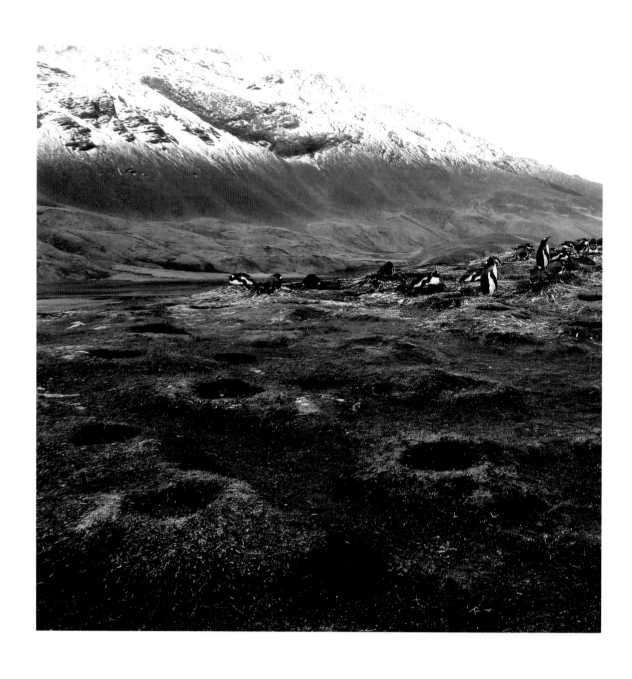

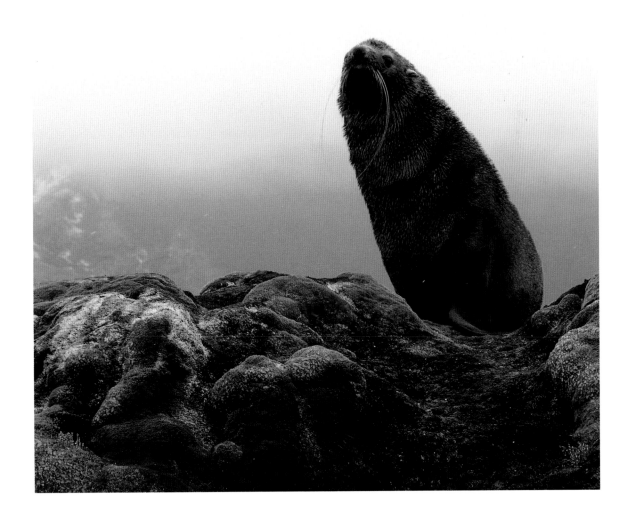

# SHACKLETON'S WATERFALL

Not assigned (yet didn't ask) to the group that retraces his steps from
Fortuna, summits, imagines the dawn factory whistle, their relief at
blubber-stench & slide to rescue, *I am Shackleton* to the station master's
question. Forbidden to walk the ruins—asbestos & loose metal katabatic-
tossed like playing cards. Stare down fur seals' territorial yellow-grin
whimper-threat, skill cribbed from L, new & so still part sham. Walk guests
upvalley. Reindeer, introduced & acclimated, gangle November's summer
green. Drifted penguin molt. Shed antlers. North/South. Next year, the deer
will be removed, status slid to *invasive.*

> falls fall to outwash
> cliff-foot, two pintails dabble
> their solitary home

Sir Ernest Shackleton (known as "The Boss") and a few men aboard the small dory *James Caird* sailed hundreds
of miles in abysmal conditions and hit this island they were aiming for, thus saving all of his crew. But wait.
They landed on the wrong side of the island and had to hike over its mountains and down to the protected east
side, where all the whalers had their stations. They made it. Katabatic winds are a localized downward swoop of
cold air very common on/near glaciers. The South Georgia pintail, a dabbling duck, is endemic to the islands.
In 2012–2013, the first attempt to begin reindeer removal was launched.

# GRAVESIDE

Here & lonely for what had, home, been yearned. A sea apart from the land of documented firsts (continental landing, overwintering, geographic pole, magnetic pole, continental crossing, kite-ski, solo this & that), now my first self-denial: Shackleton's grave.

Ferry over bins of flutes & champagne. Butlers, parkas zipped over morning coats, urge *gun it*. Gusts strafe the harbor, twist up waterspouts, howl around careened factories (retired). The historian got married here thus holds emotional claim, masters ceremonies. B says she'll watch my boat, let me stand outside picket, go lay eyes on the starred stone. But I don't go. Tired. Already. This, like this, in this way, is not my pilgrimage.

<div align="center">

oil-green grass, rib-white fence
one marker a pillar among markers
above the bone cobble

</div>

---

Grytviken was a major whaling port on South Georgia. Sir Ernest Shackleton organized his rescue effort of the men left on Elephant Island from this port, and his widow buried him in the whaler's cemetery when he died on a return voyage to Antarctica in 1922. His grave marker is a rectangular pillar of granite marked by a compass rose–like star. To "careen" a boat means to beach it in order to repair it or, in the sense used here, to retire it.

## On Another Ship, Elsewhere, in the Past

Twenty-four. Temp job stripping ships for NOAA in Lake Union. From those weeks, only watch clock & its keys kept.

each summer now
mold blooms the cracked leather strap
and I vinegar it

Who carried the heavy medallion loud rounds of deck after deck? Who paused at each station, turned key bolted and chained to bulkhead, thus clocking location and time on tape to be turned after watch over to the officer? Can't remember where on the decommissioned hulk I found it. Wanted that sailor's life. Spent days hauling thin twin mattresses, snarls of phone wires, huge whisks and spatulas (oh, those, too, kept) on ships sold to Argentina. Dreaming.

Who was I then, young, adrift? Days following the floor buffer's pulsed circles down linoleum companionways, arms humming the bus ride back to a room at my grandmother's where I hid, cried, and tried to play guitar. Not sure what else I've kept from that liminal time, what other souvenirs of an almost-life. Almost an AB, almost Tasmania & the long sea-path, almost but for Clinton's government shutdown which kept ships at dock and sent me to other work, almost a love that lasted.

I was willing, then, to do whatever, whatever.

---

AB is an acronym for an able seaman (formerly able-bodied), a rank in the merchant marine. To get AB certified, one must demonstrate sea time (minimum: 6 months), pass a physical, and pass an exam that covers things like splicing wire and firefighting at sea.

## Getting Ready I: *Standby 5 a.m.*

socks: 2 pr, toe warmers between

long underwear: 2 pr

maybe pants over?

shirts: 5 (silk, cotton, polypro, wool, zip neck poly)

neck gaiter

down underjacket

neoprene chest waders (still clammy)

float coat

hat (which? peer the porthole    wind check    wool or ballcap? sheepskin
    that, last trip, I snagged from lost & found?)

sunglasses

flip-top mitt-gloves

binoculars

radio (left arm through strap, strap behind neck so mouthpiece dangles by
    right ear)

lip balm breast pocketed

waterproof pack, carabiner on grab strap

in pack:

    gps big camera little camera digital recorder

    hand lens bird guide spare gloves first aid kit

    (if assigned) water hanky no snacks.

    no snacks allowed ashore

# FORTUNA

Last contract weathered out from full landing but had hikers to retrieve so launched a boat. Watched from side gate. Waves waves broke over the returning bow, washed all in fjord-milk. This time: idyllic. A world from Stromness rust, all fur seals, all kings.

Landing-stationed: catch boats, police perimeter, sort life jackets, warn. Beach a geyser field of fur seal bulls. Each primed to erupt at, around his females. One mounts pumps pumps pumps pumps silent & flank-flesh joggling. A stipple of us shush, point cameras set to *motion* until cow bites up and he rolls off.

Shackleton would've missed this welcome but still had the kings & moss snowed with molt & valley funneling funneling to colony. All along, pups wrangle, knock-kneed, mink-brown & fuzzy. L calls them carpets. I think caterpillars.

<div align="center">

nuzzling sable cousins
against green tussac & dark sand
three ivory pups glow

</div>

---

Antarctic fur seals (*Arctocephalus gazella*) were thought to be entirely wiped out by the pre-whaling sealers. The population, however, has dramatically rebounded from a few individuals isolated on Bird Island, just off of South Georgia. No doubt their return was aided by the lack of krill competition in the absence of blue, fin, and other whale species. When Shackleton, Crean, and Worsley crossed over from South Georgia's west side to the east, Fortuna was the first bay they came to. There, they heard the Stromness whaling factory whistle sound over the peaks, clambered back up and down to rescue. One in about 1,000 fur seals are born with light/leucistic pelage. Not albino and usually healthy, they are called "blondies" and thrive as well or poorly as the rest of their cohort.

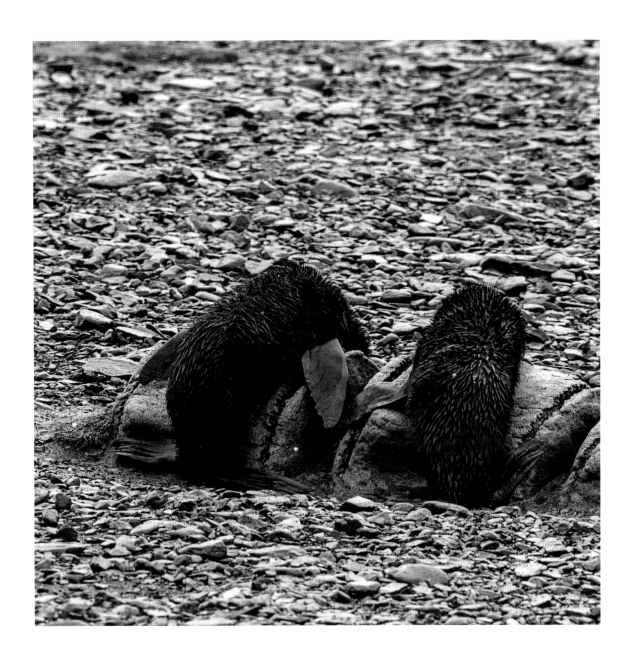

## INTERTIDAL

brittle star, krill, salp, weed

       what's left by ebb or flung

another story beneath/along

       our floated, floating stories

# GRYTVIKEN

Shuttle to research base to pick up local biologists. All gear & protocol (dry suits overkill but required). Shipboard, some troop up to lecture hall, some sneak showers in empty suites. Rat eradication talk by nonprofit head. Slides of bays, threatened birds, glacier-bounded sectors rat-impassable. The plan: X tons of poison chopper-dropped, tussac grass again (they hope) nested by endemics. Donations appreciated. Dinner at 7. Shuttle them back after & weigh anchor. Ashore, church, post office, museum already shored up, cleaned up, tourist-ready. This next restoration another (hoped) erasure. Another error blurred, overwritten, transformed.

<div align="center">

relic vats rust, loom

no pipits on steeple or trypot

*6″ whale oil / March '90*

</div>

---

The South Georgia pipit is a small, sparrow-like bird that is gone from populated areas of the Island (rats and habitat destruction are the main culprits) but holds on still on some isolated islets. There's hope that, with rat eradication, it could nest on South Georgia again. Update: That footnote was written in 2012. When I returned to South Georgia in 2016, pipit song was abundant.

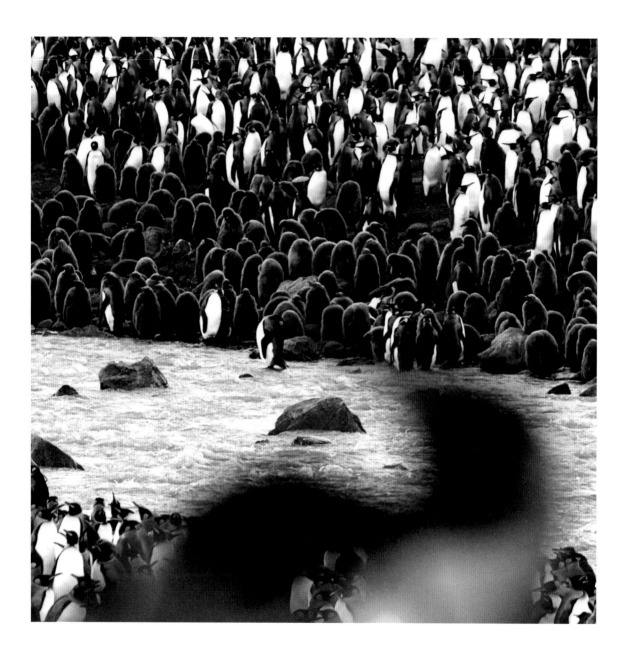

## St. Andrews Bay

Outwash plain to tidewater glacier. Steer guests wide of elephant pups, giant petrels, fur seals. Cross milky, tummled meltwater. Vertigo. A quarter-million kings on slope and valley.

> dull ice, rock scudded
> grayscale & grayscale royal
> resolving to orange

Tin ululation constant as superbowl, world cup, rock show. Oakum Boys strut temporary furs, chase returned adults for crop-slurry. A lark whistle, improbable, rises. Another. Again. Whispered aside, ashamed, to another naturalist (paid to guide I should know): *Is that?* Them. Yes. And true delight wails up. No wonder Golden Agers brought gramophones. Not to prod response. To fight sound with sound. To assert a known music.

---

King penguins in chick plumage look like fat, fluffy, brown upright pipe cleaners. They were called "Oakum Boys" because their down looked to sailors like oakum, a material used to fill cracks in the hull or between planks.

## The Blinds Must Be Closed by Dusk

In for the night. Porthole a raven's eye glinting back the lit lamp. Forgot before dinner to shade it. From bird's eye, outside, this glass disc I look to & through appears a moon which could but didn't this time tempt petrel or prion, birds that rush from burrow to wave. Are moth-like toward light. Know the danger of transitions. But all the same and despite my forgetting once again no morning call to release a thing towel-wrapped & box-burrowed by A on night watch.

<div align="center">

illicit hope:

a flumble to deck lights &

then, savior, I hold one

</div>

Nothing lured. No memory of anything leaving my hands which then would be light, warm, & perhaps, for a flitch of time, feathered.

---

Sea birds like petrels, shearwaters, and prions are drawn to lights much as moths are. Ships are thus a beacon to them, and they can become stunned or trapped on deck. In breeding areas, ships are required to shutter their windows at night to prevent such incidents.

# A Little Lost

Lunch & breakfast at dining room staff table. Radios alongside bread plates, binos under napkins, dirty jokes & manners just shy of bad. Gang, team, safety net, flirts & irritants. We one-up. We get up and leave any time we want, another's fork mid-lift, tale half-told. *See you, sucker.*

Dinner's different. Table of six plus one (of us). Manners. After-yous. Quizzed with the standard set each time: how here, where before, who left home, what next, best ever? Is this? We naturalists a specimen found on boats that aren't research but won't quite claim *cruise* (yet note lipstick on glass-rims, mints pillowed each turndown). Part of the job, sometimes fun.

Learned strategy: plot a course for the cruise. The Australians the gay couple the Brits with kids. Steer clear of second honeymooners (you're not wanted). Beware competitive dressers and the shy (nice but too much work). Beg off dessert to get out by ten & check staff whiteboard: first ops 6 a.m., standby 5:30.

# Cooper Bay

Yes yes chinstraps yes yes macaronis, hatchet-billed, oh yes kelp leathery, rock-bound & stirred in surge but even more even more the *Macrocystis* forest further off that yearned fast toward light since fall's ice mowed it. Giant petrels bathe & snap snap at isopods. We drift, a dark cloud above fronds, peer through for treasure & find trove:

> thumbnail-sized & sheened
> pink clams cling to stipe and blade
> this spring's blossoms

*Gaimardia trapesina*. Maybe arrived from Falklands on drift-wrack. Described the year Alabama became state, Spain gave up Florida, *Rip Van Winkle* became. Lamarck wrote: *Branchiae ample. Foot linguiform, and capable of great extension. Mouth . . . with labial appendage on each side. Rectum appeared to traverse the heart, and to terminate just behind it. The heart itself is attenuated at both ends.*

> *the heart itself is attenuated at both ends*

---

The bull kelp present on South Georgia is *Macrocystic pyrifera*. It is one of the fastest growing things on the planet, up to half a meter a day. Lamarck, in addition to describing the clam/mussel, is known as the man to have first used the term "biology" in its modern sense. These words are taken from his 1819 description of the closely-related *Modiola trapesina*.

## Getting Ready II: *You*

Our fleet black boats zip out & you watch from deck turn back to book sip
  coffee sleep prep as we schlep shore gear (tents, rations, flares, heavy
  heavy emergency water).

You are in a group, numbered—one of four—kin, affinity, language all fac-
  tored.

Two rounds of ops. Either your shipmates in ship-branded gear head out or you
  line up at side gate, squint out as Security lets you, few by few, down
  gangway to Zodiac shuttle.

Now the little boat's bow rides up on shore, engine cut.

Wait. Not yet.

You must receive the EL's briefing (where not to wander, animal protocol, hike
  options, last shuttle). Then you're allowed ashore.

Quick quick ditch life jacket extend poles adjust layers set ISO.

Find a way to arrive before your turn is over.

Like us. Like us.

---

IAATO limits most landing sites in Antarctica to 100 or fewer people ashore at once. Most "expedition ships" carry 120 or fewer guests. EL stands for Expedition Leader. While the ship's captain is ultimately in charge of everything and makes all final decisions, the EL is nearly the captain's equal and, in consultation with the captain and the home office, determines the trip's itinerary and daily scheduling.

## Safety Induction

Each contract, required. Routine. Five vertical divisions for fire. Two ways—auto, manual—to operate watertight doors. How to be found if. How to alarm if. 1970s hypothermia video. Plaid Alaska mustached fishermen warming the dunked crewmate, stripped down, body to body in blankets on galley deck, tucked tight. Corporate pollution video, whistleblowing video, fire safety video narrated by shiny-faced man with Scottish accent who calls captain "manager" and thus can't be trusted to know shit-all.

Twelve dots on radar = *ship in trouble*. What to do if. Who to call if. Spa girl, engineer, chambermaid, butler, staff assistant, me. What to do if. Sign. Sign. Feel the force of the watertight door, closing.

<div align="center">

are we pretending
or are we bored?

</div>

---

According to this particular video, there are 150 fires/explosions on merchant ships each year, killing 450 people per year.

## The Crew Is Banned from Shore

Alone ashore as guests muster aboard, the naturalists loll in weak sun, feign blubber (padded float-coat, neoprene waders), self as not-self, as wildlife. Seal pups hump over, nuzzle ankle, knee. Clamber a lap. The naturalists stay still, seal, inhuman & at the edge of wrong until the first engine-hum whines near. Then stand, assume self again. Apart, alert, exemplary.

<div style="text-align:center">

between *few, all*
a crevasse deep with shadow
none want to plumb

</div>

Midday. Landing over. Back aboard, a seaman glares. D says some guest saw a waiter/sailor/engineer draped over a seal. Worse, Facebook shows profiles updated, jacket logos clear. The captain is unilateral: no crew ashore until another (another) training. PowerPoint. Rules voiced slow to clamber through languages. Paper signed by each: understood. Agreed. Innocence not excuse. Again acknowledge the self as vector of all (unintended) harm.

---

It may seem benign to sit and wait for animals to become habituated and curious, but it's a thin line. At what point does someone step over into harassment? At what point is harm done and energy needed for play-fighting or foraging expended upon the curiosity of tourists (naturalists included)? Young elephant seals ("weaners") are particularly thigmotactic and, weaned from their mothers, will nuzzle anything. Before going ashore, all visitors (this includes crew) must watch a briefing about proper behavior at landing sites.

## On Another Ship, Elsewhere, in the Past

No remembered lurch crunch though there must have been when hull met rock, uncharted, 2 a.m.-ish, short summer dark. Tide in Alaska ebb, many meters to fall quick. Old hand four (five? seven?) weeks into six-month deckhand contract. Had drilled for it: *abandon ship*.

No. Did feel it. Lurched up from book in crew lounge to bridge, down belowdecks for gear, up to life rafts strapped to top deck. Crane whine lowering Zodiacs. Slip open (the name the name the name can feel cold stainless, slick, tension on mouth numb hands weak what what what is it called) pelican hook. Count together to heave over plastic shell. Pops open on impact, orange tent inflates, floats upside down. Right it. Drag to stern by thin painter. Ladder too high above water. Jury-rig semi-teetering steps. Guests lined up with coats, pills, bags (not allowed). Help clamber down, in.

> dark, damp floor sags
> soft, awkward—one woman hauled over lip
> blush of pink nylon panties

Boat tug-propped against wreck. Stay with mate, engineer, another deckie. Coats list from companionway hooks. Silence, waves, hull groan. Hours. Slow tidal refloat and the next day resume.

> snuck, ziplocked, shoved
> twin buds forced by notebook corners
> bloom on upper thighs

## Here/Elsewhere

At sea. Horizon & albatross. Stern wake & petrel. So many so many such soaring. Or the same few? Hard to say. In news: birds drawn by longline bait, hooked, pulled into deep, unrecoverable plunge. Or, polyethylene wave-shredded to chum then plucked up, flown to nest, voided into chick gape as food. And thus what lasts: plastic-gut carcasses, feather & bone around a bright center that will never degrade enough.

> albatross alongside—
> a cockeyed feather again
> allows one reckoning

Later, alone on deck with tea. Travel mug from home set on rail. A swell. Skitter & rattle—gone. This message of our passage, of what I now carry.

---

Various petrel species arrive in Antarctic waters with stomachs polluted by plastics ingested elsewhere. They break the plastic down into smaller pieces, which they then excrete. But the toxic substances remain behind in their intestines. A side effect of this digestion rate is that birds contribute to the spreading of plastic waste into waters that otherwise would not have any.

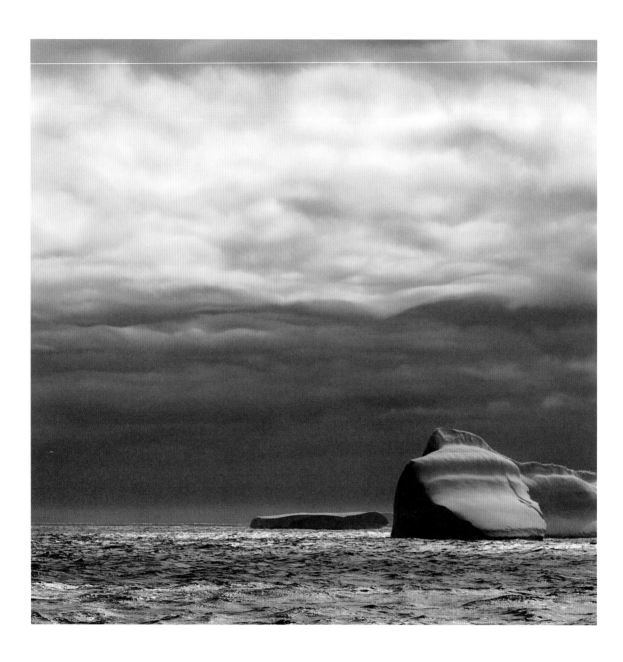

# Sea Day

*dissolve dissolve*

what the water offers

what I'd like to take it up on

---

Whenever I see an iceberg, I think of Elizabeth Bishop's poem, "The Imaginary Iceberg": "We'd rather have the iceberg than the ship, / although it meant the end of travel." Wouldn't you?

# III.

## THE PENINSULA, ETC.
## (THERE & BACK, THERE & BACK: REPEAT)

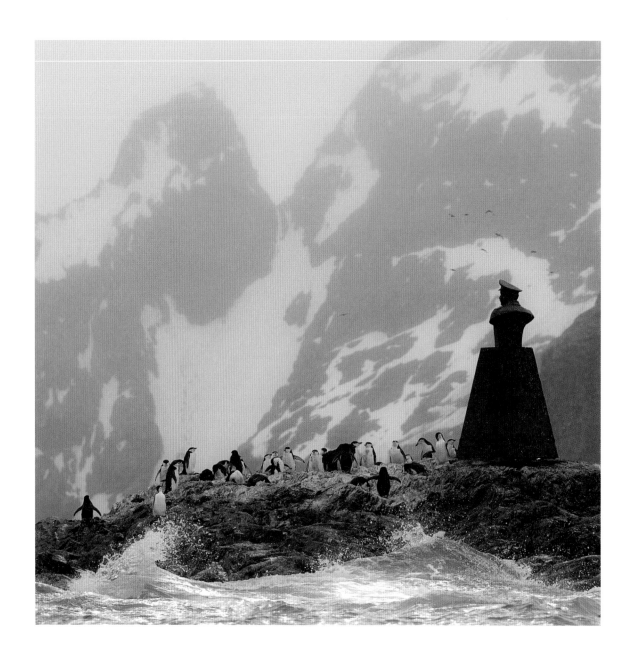

## Point Wild, Elephant Island

Rough. Chop on top of swell. Passengers stagger the gangway. I idle bow in, wait my turn for pickup. Gust off the glacier—hunch away—slaps my shoulder like a stupid cousin. Water down neck. Now six with me. Russians. None with much English. What if what if what if in the pulse between *Sit* :: translation :: sitting?

<div align="center">
surly ice licks down<br>
tastes chop, fractures to brash<br>
spittle hisses the keel
</div>

Weddell seals snooze in shallows. Chinstraps crow. Back for another round. We gawk at the ice-free fingernail of beach below the statue. Rough base, bronze torso. Takes almost all space they had to watch horizon's hope. Stomp for warmth. Blackborow, I think of you, toes snipped. My privilege to enjoy (yes, despite & because) short discomfort. Wind's up, sea crests slung. The others say it's always like this here. All crossing, they scheme to avoid it.

---

It was on this toenail of land that Sir Ernest Shackleton's crew waited 137 days for "The Boss" to return and rescue them. Blackborow was a stowaway on Shackleton's ship, the *Endurance*, and the first to set foot on Elephant Island as well as the only crewmember to get gangrene and, as a result, had all the toes of his left foot amputated during the crew's time on Elephant Island.

## First Landing: Brown Bluff

Shuttle driver, ship to shore. Get them out, back before wind kicks, ice shuts, flurries blind. First Continental Landing. They walk the narrow strip. I nudge aside growlers, clear landing site for departure. Idle offshore. Radio-squawk. Another load to the beach. Boat emptied, attention turned, *Don't look* hissed to T, holding my bow. Swing boots over port pontoon. Into water. Onto stone. Set foot.

> dream, story—supplanted
> three rocks, gold with lichen
> my unmarked marker

*OK.* Swing over & in, engine on, reversed. Off again. I want to be not competent or knowledgeable. Not watched as guide. Raw. Responsive. Sentimental. A pilgrim. Bashō at his shrine alone with Sora, a cricket cricketing under an old helmet.

---

"Growler" is the term for fragments of ice roughly the size of a grand piano that extend less than one meter above the sea surface (with, of course, 90% of their mass beneath). Bashō, in his writings, describes visiting an abandoned shrine in which a cricket calls beneath an old war helmet.

# Encounter: Leopard Seal

Presence astern. Brown shadow under skeg, unmistakable despite until now
unseen. It lifts to stare. Flexes nares for breath. Stares. Orde-Lees, Mawson,
the rest no preparation for menace at my transom. It humps up, dives under.
Rises. Huge nostrils. Eyes. I lever into gear, wonder about chase instinct—
those cats my dad's sweet dog can't help but kill—

<div align="center">

alive alive enlivened
low clouds give up, gleam, part
admit the sun's presence

</div>

There are many stories of leopard seals bursting up out of the sea and onto the ice to chase (and sometimes attack) people. The most famous account (at least in my mind) is that of Thomas Orde-Lees on Shackleton's 1914–1917 expedition. Alternately, there are stories of encounters with leopard seals in which the seal proffers killed-penguin "gifts" of friendship to human divers.

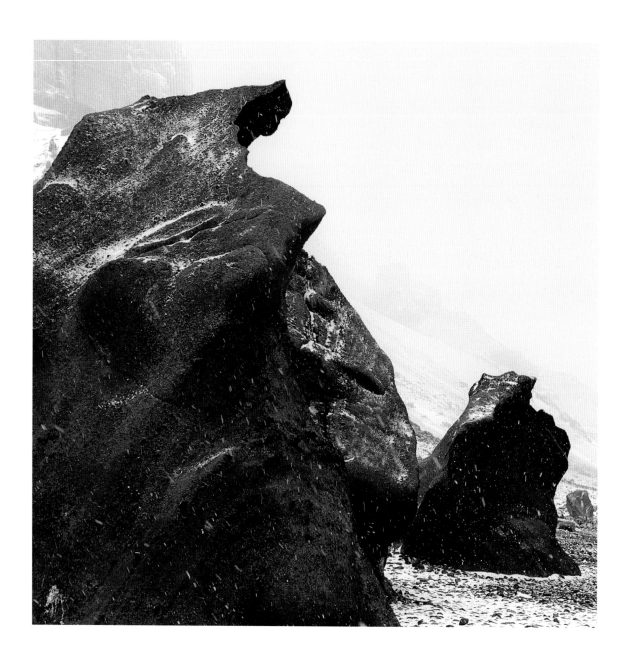

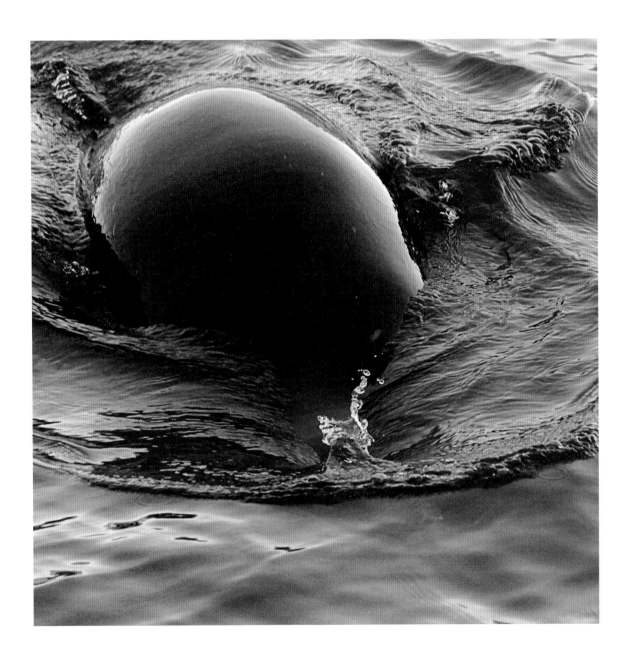

## ONE TRIP

wet flurries      first landing

a couple from India

confesses it's their last

continent, first snow

## On Another Ship, Elsewhere, in the Past

Bunk-tucked under brown plaid blanket, long-light still silvering on. Late.
Running east of sea ice into fog and tomorrow's hope: no bears on shore.
Waft of bad plumbing, ship-sounds, then

> night yowled open
> a woman's fear echoing
> down dim companionway

Bolt up. In curtain-filtered gloom, M & I lock eyes, listen for another.
Another. Language foreign but not tone. Legs swung, jacket pulled on in
after-silence, feet into boots. Open the door. No other door opens. Step out.
No other door. Mascara-streaked crewmember in pink torn sweats. Man in
boiler suit walking away—seaman? engineer?—a glare before gone. Usher
her back to our cabin. Calm. Calm. Calming. Then she wants to leave.
Leaves. Across hall, Expedition Leader cracks open his door, asks what,
says he'll talk to Captain. But but but but is that help or harm? If she leaves,
contract considered *broken* & she'll have to swallow ticket fare. If she stays
. . . she stays. Him? Him? Two look alike, blue-eyed, buzz-cut, and I can't tell.

> who's on crane, tanking gas, catching my bow
> in rough swell at side gate
> who is watching

---

In the Arctic, when there are polar bears ashore, landings are cancelled. A boiler suit is the working uniform
worn by most people in the engineering department and, occasionally, deckhands.

## AFTER KINNES COVE

Wrecked from it. Yesterday, set out on glass to putter the cove. Dallying, admiring ice and shore, cutting the engine to hear melt drip. Then, in minutes, it blew to shit. All of us too far from the ship. Spindrift the proper but vastly wrong word for what screamed over water, made flotsam of us. Top gusts: 95 kts. Not sure how long we pounded into wind and crests as the ship repositioned, drifted in, repositioned to make a lee, let us unload and hopefully hoist. Joked at the tiller to make it seem less dire. Cringed at guests' crest-cheers, the breaker-over-back whoop (thankful for, resentful of that spirit). Clawed the tiller Blackburn-like. Got passengers back, got J into bow as ballast, kept close astern ship in prop-smoothed wake, behind inaccessible refuge. Stupid fucking way to die, in the place of my fancies, away.

<div style="text-align:center">

dissipating
in spume & katabatic assault
the pulse still burns

</div>

*Kinnes Cove.* Muttered when shit goes sideways, our new shared curse.

---

Howard Blackburn was famous for being lost at sea and rowing his dory through weather so awful that his hands froze to the oars. Actually, he shaped his hands to a grip so that, even when he lost sensation, he could still keep rowing.

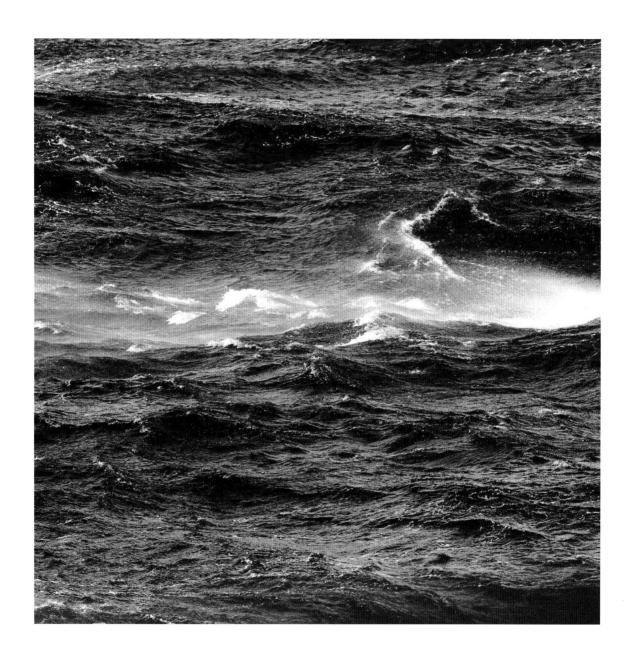

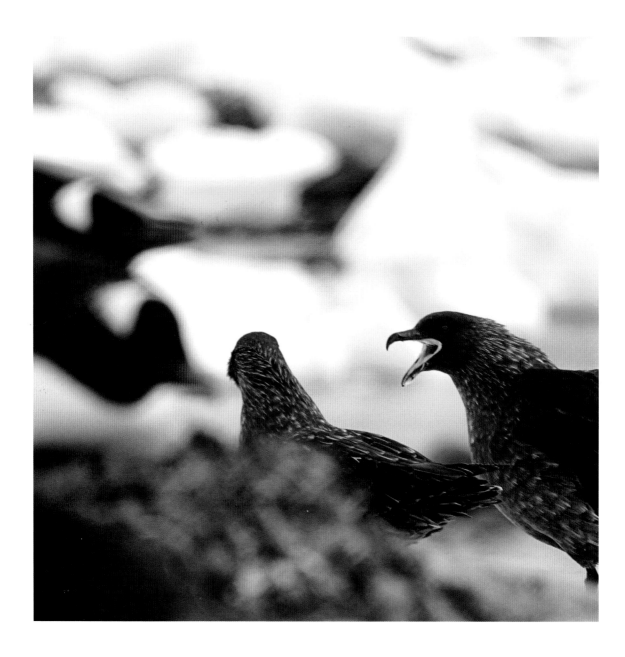

# CUVERVILLE ISLAND

Rookery lookout. Perched off the brick-orange gentoo path as signpost/
playground monitor/traffic control. Red coats (how guests are honored and
marked) march the flagged white path staff stomped. Some penguins get
confused and use it, too, instead of their dirty own. Skuas wing over & all
gentoo bills lift—austral forest, armed fort, outcry. One skua distracts. The
other circles, wedges egg into gape.

cacophony flightless & flying
red fluid hooked from broken shell

My cabin mate calls herself "super skua." We skua crew mess pastries and
cheese, skua toe warmers, gloves. I skuaed her chocolate. Can't help it. Skua
time to sneak an email check. Home, how are you? Remember me? What
menace wings over, distracting? What menace have you (have I) become?

# GETTING READY III: *AFTERNOON LECTURE*

test the sound file

test the video file

test the Mac-made presentation on the ship's PC

and myself? tested enough to stand on stage as expert?

review notes, review notes, review notes in case

change into clean shirt & arrive a half hour prior

battery check microphone

remote slide advancer check

does it play on the stateroom TVs? check the observation lounge monitor

order a coffee to kill time, try and not appear anxious and watch-checking

fill water bottle

hello, welcome, here is what I've prepared what I thought back home before
   might educate and entertain

(too wonky? dumbed down? too silly earnest dull light?)

how many attending? try not to take it personally. rough seas, early
   morning, midday nap

talk

enthuse

inform

query

be vulnerable and hopeful that some moment might snag, some image
   might spark, light might be shone and then linger, glimmering
   still once home, be fanned toward an act that will blaze

# Lecture Notes

Attending for moral support: back row, notebook open, binoculars ready for small text on screens. Sea days, three or four of these on penguin evolution, continental drift, toothfish fishery, the feats/defeats of Shackleton and Scott who bumbled it and won no matter because here we are, still telling their stories. This one I've heard before but from another voice and so I sit, drift, duck, glance out—

> prised wedge of light
> prion, albatross, horizon
> ongoing beyond

In the dim plush, head-nodding, nap-tilted ears, restless gestures for another coffee tea sparkling wine. Someone takes notes (what of mine's been jotted?), someone backchannels & fact-checks, someone knits. The monitor repeats for any asprawl in their beds, unattended. Screen glow of someone editing photos—delete, delete, enhance, keyword, rotate, sharpen, delete— some, I swear, identical to mine which last night I culled.

> slight shifts of angle, light
> our distinct erasures
> define us

# NEKO HARBOR

Here. The anticipated harbor. Here where Lynne Cox swam 1.22 miles. Pushed heart pushed breath pushed self against cold's hard shove. A deep thrum to enter water she entered. Peer out cargo door, suss which gloves, boots, hat the day orders. Water dimensional with brash, growlers, bergs. H saw the biggest calving of her life here—nearly the glacier's whole face. Surge wrapped the point. Everyone speed-stumbled into boats (none lost). To have seen it. Interminable thundered slump, hump of water mounding out high, higher, ephemeral drumlin of sea and ice. Other stories heave to mind, trees wave-snapped at 524 meters in Lituya. Flare a stern-facing deckhand spotted as we rode the brash-swell out of Tracy Arm (turned, rescued the wrecked shore-hauled boat & three). This harbor bowl musters it all: history, ice, us, crabeaters, terns, my yearning.

                    prop bangs ice all afternoon
                —strange Morse—no one seems to care
                        so I keep going

The long-distance swimmer Lynne Cox has swum amazing distances across many of the world's oceans. Although her 2002 swim in Neko Harbor was not long, it was long to be immersed in water of that temperature without a wetsuit. On July 9, 1958, after an earthquake caused a rockslide, one of the largest waves in modern history sloshed up Lituya Bay, on the northern Southeast Alaska coast between Cape Spencer and Yakutat.

# GERLACHE STRAIT

Killer whales. Killer whales to port at dinner. Warm from wine that never
fully disappears from stemless (set out for rough seas) glasses. Rush, jostle,
sidestep tables & coffee station, crane over someone's salad to peer through
stern windows, yearn at wake. Mother and calf humpback in our prop wash,
sickle fins on either side.

<div align="center">

sheened evening water

pewter, polished, reflecting

so hiding what roils

</div>

The ship doesn't slow or turn. Settle back, unsettled, to final course. What
now? (Who's on watch? Did they see? How could they not? Captain or Hotel
Manager deciding to not slow? Did EL know?) Steer conversation elsewhere.
A guest shows off his wedding ring: eagle, loon, salmon, orca in form line
design. His wife's with diamonds punctuating. What do these patterns say
here, in this place with no such peopled retellings, just raw hunt which ed-
dies the solution we sail through . . .

---

Pacific Northwest coast peoples developed a unique art of stylized representation called "form line design"—
totem poles are perhaps the most familiar example of this art. Antarctica has no indigenous population,
unlike any other continent on Earth.

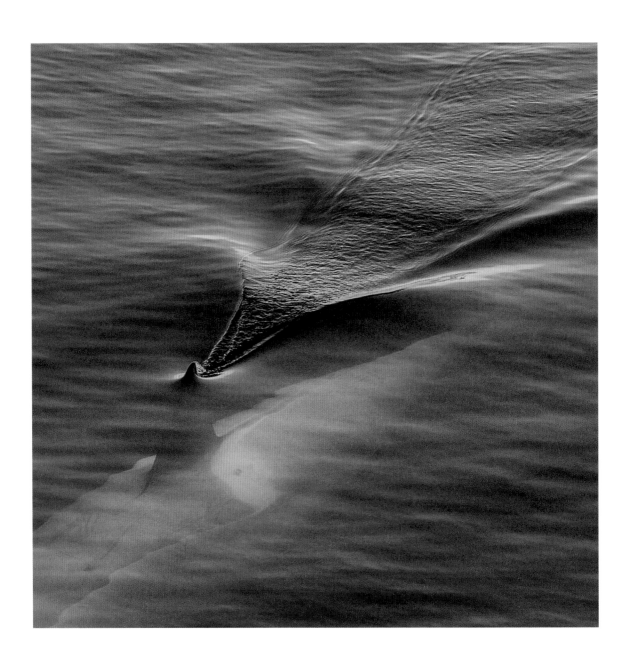

# Gerlache Small Type B

4–8 a.m. with J on deck, wind in teeth. Nothing but numb faces for it. Later, meant to leave morning landing via Errera Channel but ice-blocked. So out again into Gerlache. So glassing again. Distant shimmer shimmers into storm petrels. Hundreds patter & skuas swoop above what's invisible beneath mirror-calm. Forget the leopard seal asleep too far to *really* see. Just beyond squint-distance, squinting, a fin? Three, seven, ten erratic and slow. Fumble radio and for once time and weather agree: worth it. Ship slows, turns. Announcement wakes the decks to crowd. Minke cuts across steady, easy, then the orca turn toward us. The orca turn toward us. Come down alongside slow. O. Nothing like anything I've. Small, so small and chocolate-milk brown and scarred and Eva you'd have loved to have—

> travelers, arriving
> met with every flag
> our bodies can fly

---

Eva Saulitis, who died of cancer in 2016 at the age of 52, was a poet, essayist, and killer whale biologist who spent her life studying the mammal-eating orcas of Prince William Sound, an endeavor recorded in her book, *Into Great Silence: A Memoir of Discovery and Loss among Vanishing Orcas.* She never visited Antarctica. She was a dear friend.

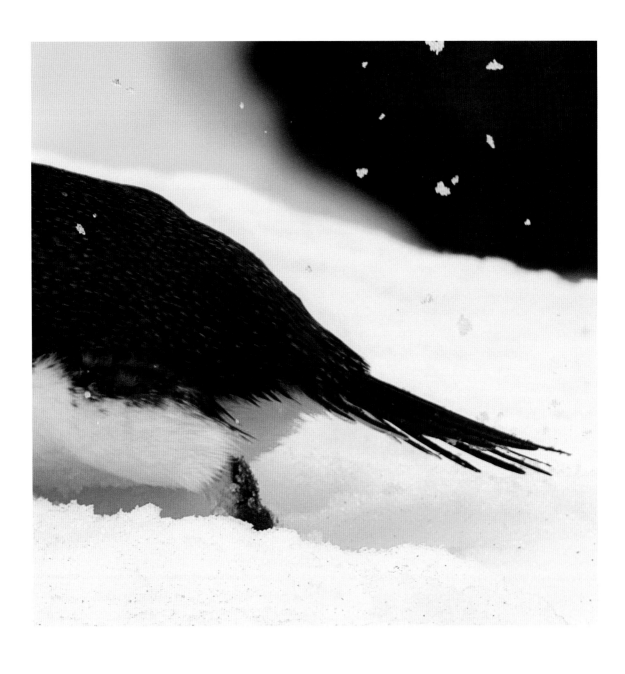

# HALF MOON ISLAND

Crossing guard duty on our path that crosses the chinstrap path as they pass from rookery (elevation: 100 m) to sea (elevation: ±0): *Wait. Wait. Wait.* Penguins have right of way. Never mind lens size/weight, salon appointment, bladder, chill. Birds toboggan down scat-filthy, waddle up wave-scrubbed. Slope a 35. Maybe 30. *Wait. Wait. Cross. Cross now. Careful.* Don't stop & squat to eye level, yearn for reaction, recognition.

> two ribbons cross snow
> each (stained & white) packed slick
> what mark, now, is strange?

So that's an hour. Then released to see what everyone has seen over the ridge & is discovery to me: young Weddell seal. Wet. Sleek. Squirming. It nuzzles an outcropping. It sings. It does. Squirms. Blinks big, dark eyes. Sings. Didn't know out of the water it would. Didn't. Gloriously failed again by study.

---

You really should look up the underwater vocalizations of Weddell seals. Unearthly.

# GETTING READY IV: *GUEST DINNER*

check time & sea state & legs. shave? (stockings snagged & laddered by bed
     velcro so abandoned)

shower (wash underwear while rinsing)

where's the cabinmate? (*volume, more volume* her curling iron at bangs,
     euro-dance pumping from mini-speakers)

dress

heels (what sea state?)

lucky necklace

*shot for courage?* yes

cabinmate at shared desk: eyeliner, mascara, glittery cream on her chest, bindi

at the mirror: check hair check lipstick check eyes (red but nothing to do about
     that)

grab thumb drive with mini-talk for cocktail hour recap. what today? wings
     & flying. how albatross, how Jean Marie Le Bris, humpback pectorals
     & how that engineer saw their bumps on the leading edge not the
     trailing & now Frank Fish's turbine blades . . .

*ready*?

sway the corridor

climb three flights

sway to the bar for a glass of red before waiters get busy serving

ready

# Identity Politics I

All the maids are Filipino, ditto bartenders, deckhands, some engineers. Sommelier from the Marquesas. Officers mostly Eastern European, Scandinavian. Except the purser. He's Greek (cue the joke trotted out at intros in year of debt crisis). Butlers Indian. The tallest of them a fantastic dancer (this to be discovered one New Year's Eve crew party when riotously drunk). Argentinian gift shop manager. South African hairdresser. French concierge & *maître d'*. So many cabals. So many bosses and job-linked favors, disfavors simmering. Expedition staff: German, South African, American, Canadian, Dutch, Argentinian. One admitted queer, me. One known closeted. Can't remember the ship's flag—one of the cheap ports. We converge. Here on this all-owned land. Here on this unbridled ocean. Here on this world unto itself.

---

Many countries offer very inexpensive ship registration ("one of the cheap ports"). Very few expedition travel ships are registered in the United States. Many are registered in the Bahamas, Panama, Bermuda, Malta, and Italy (the top ports as of 2011).

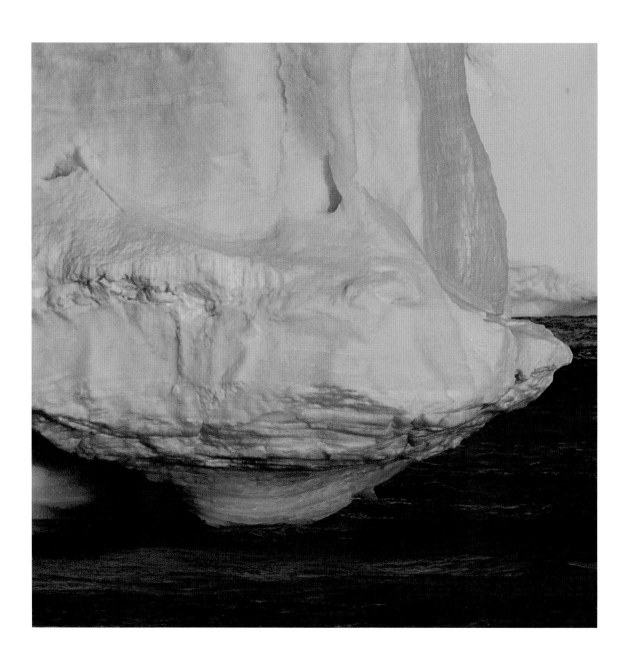

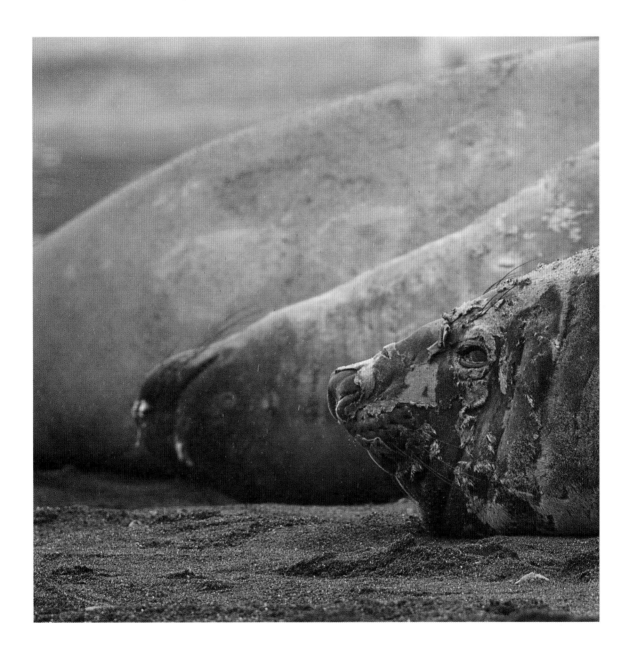

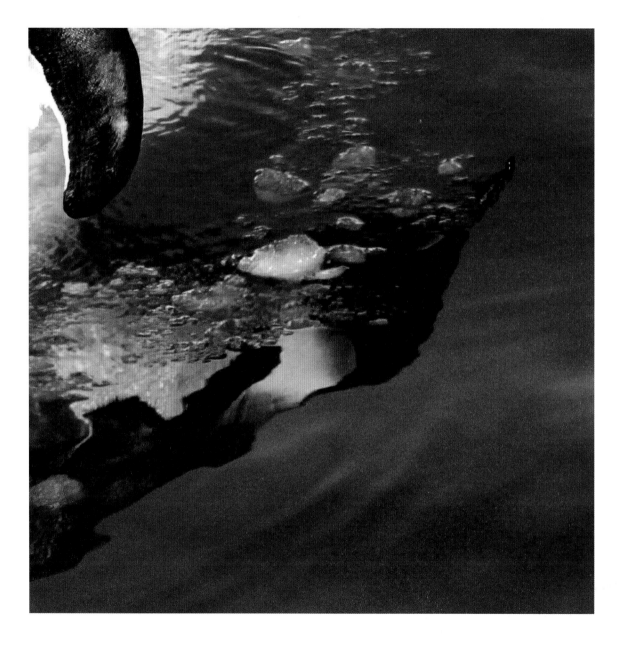

## EMPEROR PENGUINS AT SNOW HILL ISLAND

All week, emails flung to satellites, slung down, ship to sky to ship—*Seen here*. For once, the Weddell open to latitude, day scheduled ours, conditions clear and calm. Approached pack. All eyes on deck, binos keeping distance less distant. Who spots them? H? E? Not me. Then almost too easy, too plain

<div align="center">

tall hunch at ice-edge
no, no brilliance at throat, beak
closer, brilliant

</div>

Thinking of Cherry, his first by winter's moonlight & aurora. Don't go in for offered coffee, biscuits, spiked cocoa. Or to shout home (if reception, if time on the purchased card) this historic. Emperor penguins! Sea ice bumps to horizon. Last year's shuffling tabulars trapped in old pack. Connected, apart. Why are we here? Decadence. Delight. Desire. A tourist ship discovered this colony just ten years ago. *Discovered*. Could have been us. Could have.

---

Apsley Cherry-Garrard, a member of Scott's expedition, was the first to ever see emperor penguins incubating their eggs during the Antarctic winter. He writes about it beautifully in *The Worst Journey in the World*. Tabular icebergs are enormous, flat-topped ice-islands that break off from an ice shelf. It was the *Kapitan Khlebnikov* that first discovered the small emperor rookery on Snow Hill. Since then, other rookeries have been discovered by satellite imagery (they look for the poop stains on the snow).

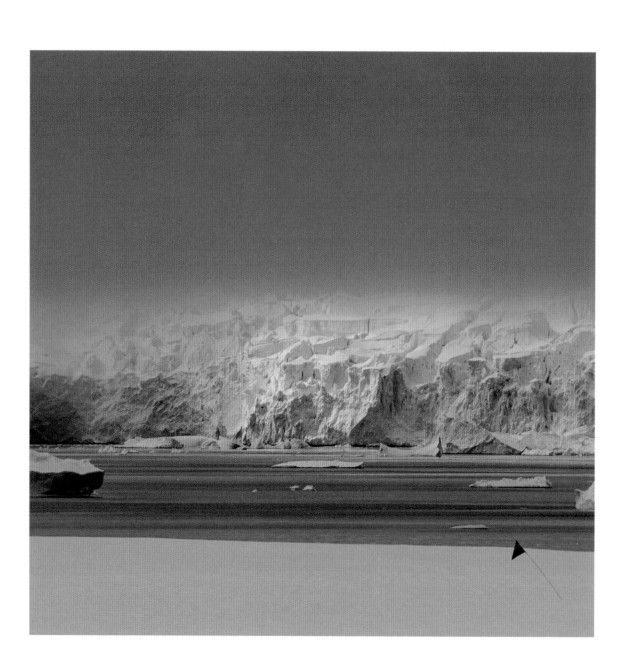

## First Walk on Sea Ice

Weeks watching the bow cut through what's weak enough for not-quite-breaker us (hull Lloyd's Register ice-class notation 1A). Captain's an old hand at reading leads, ran supply ships somewhere north of Europe in seas that gathered ice like a hoarder does newspapers: stacked, falling, becoming architecture. Now we're bow-in. Wedged. Docked in a slip custom fit. How to disembark? No gangway lowered right to it for romantic arrival (unsafe). Lower boats to open water abaft of midships, shuttle the ten yards from side gate to landing. I stick the flags they give, pulled from their quiver, & ring what should be safe to wander. How do I know?

<div align="center">

fluttered border
tracks of seals disappearing
over another edge

</div>

Pose under anchor, camera angled for illusion of heft, for max prow-loom. Run, flop angels, throw snowballs. Someone brings out a tennis set. Play on this non-land as we haven't on the continent, sure our tracks will soon be gone.

# DISCLOSURE

snow, you old gossip

# AITCHO ISLANDS

Sneeze of a place, "officially unnamed" scrawl we scope, land, and wander. Tide ebbs. Approach complicates to serrations each boat must dodge, weave. Easier to stay offshore until called. Kill engine, drift, lounge athwart, alert, feet up on landward pontoon until breeze pushes to danger, pulls to steer away.

old ice drifts in
five crabeaters nap on crumble—
seals, berg scarred

If quiet, if low, if unsudden, an approach possible. Clutch ahead to north edge, drift the face. Ice red with seals' krill-shit. Chill sun burrows darkness to melt. All five marked by teeth on flank & belly, deep but so long past source that none nurse them, none startle the flinch of the once-got. A female stretches her foreflipper, eyes closed. Past, I recognize you.

---

Aitcho was named in 1900 after the Admiralty Hydrographic Office (the "H.O."). Crabeater seals actually eat krill, not crabs. Scars thought to be inflicted by leopard seals attacking young crabeaters are often seen on their flanks.

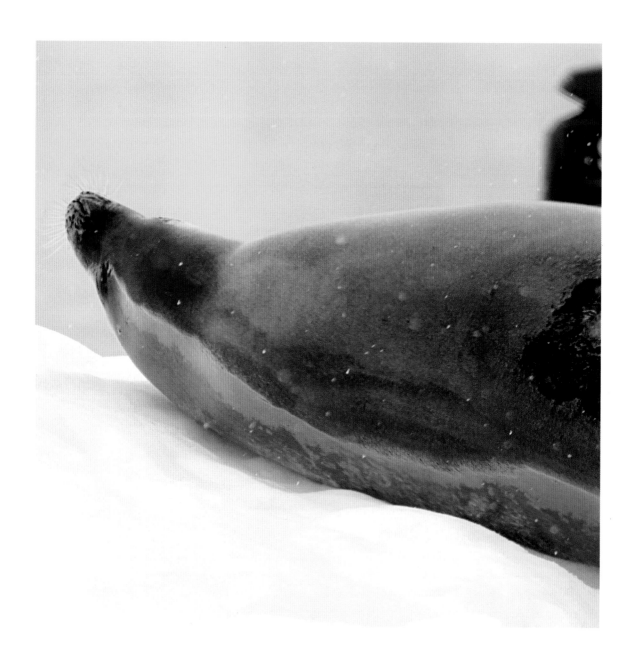

## The Fossil Whale

Northbound Drake. Two sea days. Restless hum of homeward restuffing (guests), reset and gear up for the next (us). Lecture. Lecture. Boot & gear return. In secret, when roommate's busy elsewhere, hold open clothbound red-ribbon-marked *Moby-Dick* from least-used ship library shelf (classics), hunch over digital recorder & read what's assigned me: Chapter 104. Melville's sentences roil strange, vast, intestinal. Background clang of waves against hull.

*Such, and so magnifying,*
*is the virtue of a large and liberal theme!*
*We expand to its bulk.*

First within voyage of firsts. Story within sea-borne story. We expand. Are changed by passage and place. I, too. Have scrawled on this ship, cracked the specked shell of job title to suck the rich, strange stuff that might become words shared. Thus this. Here.

---

In 2011, writer Philip Hoare and artist Angela Cockayne created a digital version of the Moby-Dick Big Read at www.mobydickbigread.com. On the website, each of *Moby-Dick's* 135 chapters are read out aloud by figures famous and unknown. Artistic responses accompany the recordings. The haiku is a found poem from Chapter 104 of *Moby-Dick*.

# Trapped

Approach Whalers Bay. Entrance cemented. Gray ice a raku glaze crackle of clashed raftings. Small boat buzzes from outer cliff-fold, seven aboard, huddled. How long out? How open when they left? Unlucky or dumb. Could have been us, me. Now the solution of our hull, ice-strengthened, breaking toward their ship inside. K's sailed for their outfit, knows who's likely at the tiller. But it could have been anyone, a quick tour turned long, wrong, danger & fear's deep tug masked by exclamation: *petrel! chinstrap porpoising! rock! look!* Not the solitary flubs of yore, their consequences (Scott's gap between tent and cache), but a small calamity to take as reprimand & recalibration of confidence.

> summer's winter
> sea fuses its refusal
> we rip a small seam

Scott's fatal mistake is well documented, but the Australian explorer Douglas Mawson might be less well known. He and his team attempted to reach the South Magnetic Pole in 1909. They thought they did but, once home and after reviewing their calculations, found they had not, in fact, achieved it.

## Telefon Bay

Named for a wrecked ship of coal & empty barrels, refloated. Immaterial.
Then, now. See-saw of context and history and O bright calm after morn-
ing's full-on facial sleet scour. Weddell seals, one rust-bellied, snake over
snow patches, nose-plough into cold. Long hike up to unnamed crater rim
over nearly mossless black pebble ground just four years older than me. Sun-
drunk, almost miss what's at rest below on unmelted snow in rim-shadow:
a seal.

<div align="center">

no track of tumble or climb

no story other than *is*

</div>

H remembers not there last year, but yes, earlier this. Crabeater? Weddell?
Gas-bloat, distance-shimmer, snow make it hard to say, but I've read of Dry
Valley corpses leagues inland, mummified, still mystery. Why does anyone
wander away from the known shore? Why, once away, do we not turn back?

---

Because of volcanic eruptions, all ground at Telefon is dated from 1967, which makes it a great site to study both
succession and climate change. The Dry Valleys of Antarctica's Victoria Land are known for their mysterious
seal corpses. Most are young crabeater seals, though there are some Weddells there, too.

## LOCATION UNFIXED

Albatross, albatross—what history. Whalers' haphazard messenger, furled notes bound to flighty shins. For Australia-bound steamshippers: pot-shot amusement, winged skeet.

> what did you look like falling
> plummet or cartwheel?

A kinder historic diversion: catch & ribbon one. Let it go to circle mast or smokestack, recognizable, in unfettered May dance, no pattern accrued. If caught at sea with egg inside, luck. Captain's tribute.

No need to mention Coleridge, that bird.

---

Whalers did, sometimes, tie notes to albatross shins. Maybe not an efficient mode of communication. "At length did cross an Albatross, / Thorough the fog it came; / As if it had been a Christian soul, / We hailed it in God's name." Lines from "The Rime of the Ancient Mariner," by Coleridge.

# Turnaround Day

Farewell. In sun, rain, sun the staff lines out: gangway base to bus. Metal domed treads bounce under travel-day shoes descending, departing. Roller-bags (awkward) carried by stewards. We shake hands, kiss cheeks or hug (farewell calculus of nationality, sex, fondness, formality, contagion). Then, free of tasks until three, cab it to the park with H.

Walk silent. Walk crass. Walk gossip & fast, alert to birds and hopeful for Magellanic woodpecker. Quicken at time check. Trail longer than. Us slower than. How far? All aboard when? Time pressed thin & painful as a breast for a mammogram. Bushwhack to road & thumb it. First car stops—rental with guests we'd just waved off, names already forgotten but faces familiar. They laugh, speed us back. Aboard. Re-uniformed. Embarkation. Hello. Hello. Begin again.

<div align="center">

somewhere ashore
red crest batters a dead tree
in glad repetition

</div>

Cast off. Gather at stern to watch Ushuaia's concrete & glass recede. High winds. Following sea. The port shut down after our departure. Rollers roll us east in nautical swagger.

## An Admission

Aboard, hard to stray beyond the Upstairs/Downstairs we've all used to get here. Simpler to see you, guests, as interchangeable. You leave and you leave and we get on with it. But I remember some (& not just the pains-in-the-asses). Oddballs, goofballs, sweethearts. The Aussie twitchers on deck day after fog-blind day whose jokes and obdurate bird hope made that cruddy trip ok. The sweet Brit who'd never seen whales so became my glad quest until one breath-plumed sunset (where is she where is she) in Dallmann Bay. You, stepping aboard now, recognized from . . . Svalbard? The Kurils? I'm remembering. And what tender transgression in those few (V, H) known beyond itinerary—

> landside, unpacked
> we disclose stranger selves
> in wildly hesitant light

# THE FALKLANDS: WEST POINT & SAUNDERS ISLANDS

Walk the sheep-gnawed lawn green-swaled like Scotland (never been but assumption seems permissible since, why? race and adjacent ancestry? Eng. Lit. novels read & loved?) to first albatross colony. Nests mud-stacked to strange chimneys. Rockhoppers smattered among. Eggs under all. Bills, brows, crests, clamor unexpected.

<div align="center">

beneath fierce, dark brows
a recognized tenderness
a singular hope

</div>

After, farm-made cakes & cookies on linen-laid table. Mismatched cups. Tea. Meadowlark needling the fenced square. Piña colada scent of invasive gorse, wafting. Fogged green swale. So English. Islanded. And strategic, girded by oil.

Commerson's dolphins (chubby ghosts) circle the harbor edge. Across water, fenced out: silvery tussac. Hill as it might have been before sheep & scones. Hill as we might see again on South Georgia.

<div align="center">

in softness
—temperate, familiar—
wild impatience gnaws

</div>

---

The Falkland Islands, culturally more stereotypically British than England, are a wild surprise in their rich bird and marine life. Often, ships will stop there on their way to South Georgia or even on a Peninsula trip. As inhabited/settled places, tourism there is different than Antarctica and South Georgia. On West Point, the Napier family first opened their farm, which has beautiful tussac grass and albatross colonies where the sheep are fenced out, to tourism in the late 1960s.

## Stanley

Land Rover over humped peat to penguins (one leucistic) & more tea. Sorry, bad hip. Sorry, hemorrhoid, sciatica. We must lurch to see. Poor bog-plants, time-pressed to fuel and use, ruggedly roughly beloved, smoking the low house, stove-bellied.

fawn-shouldered gentoo
aglow among countershaded usuals
nesting anyway

Seen & snapped & jarred back & we're in Stanley. Free hour before dock duty, I drift toward carolers circled under blue whale jawbone arch. Old songs. Old bones. Suddenly adrift, unmoored. Head-bent to hide unbeckoned, annoying sentimental tears.

southern midsummer
Dickensian accents sing
our distances

---

Leucism is a lack of pigment that is less extreme than albinism. It comes from a lack of melanin in the feathers/fur/hair (rather than an absence of tyrosinase in pigment cells). About one in 10,000 gentoo penguins is leucistic. The bird I saw in 2011 was reported to be still successfully breeding in 2016.

## New Island, Falklands

White sand hard packed, beach an oystercatcher-stippled crescent. Copper-sheathed ship stem sculptural, wrecked gentle. Perfect porcelain commode visible through hull hole, bright and clean and tilted. Useless. Stroll the island's saddle to bird amphitheater: albatross, rockhopper, shag. Skua working to down a downy chick headfirst, webbed feet flopping asplay of bill. In landing-prep had scanned the fact sheet & am lost still at what is unseen and surrounding and reputably underfoot nearly everywhere—

> in tunneled tussac
> millions of silent prions
> hunker until dusk

Prion, favorite pelagic, hard to see even at sea so wave-blue & white-edged, an unreality fleetingly real that tilts above wake beyond sight of land. All day, I dream you.

---

The *Protector III*, a sealing vessel, beached on New Island in 1969. The thin-billed prion (*Pachyptila belcheri*) nests on New Island, digging ~3m burrows into the hillsides. Nocturnal nesters, the adults leave the chicks in the burrows during the day while they forage at sea. New Island is most likely the most important breeding spot for these birds, representing 30% of the world population.

## JOUGLA POINT

Morning perched, foot wedged, on slick black rock. Catching boats. On hand to hand guests onto shore. Fractured grease ice gusts up the shingle, rubs in wet, brittle flex. On tongue, strong salt. Held to sky: cheap plastic rolled over bathroom windows to shy them.

strange dark water, stilled
now, held, light melting in hand
in absence, brimming

Overhead, shape & shape & shape as shags fly in with rare moss from elsewhere to mound around altricial chicks.

shock of two-tone birds aloft
shock of air against bare skin
twice vulnerable

Repetition dulls none of it. Shag, shag, shag, bright blue-eyed shag (none of us shagging).

---

Grease ice, the second stage of sea ice formation, is an oily-looking and slightly flexible skin on surface of saltwater. Blue-eyed shags (a bird similar to a cormorant) nest on Jougla Point, as they do elsewhere on the Antarctic Peninsula. Like penguins, they have black backs and white bellies, so to see them in flight is a case of constant double-taking. Shag chicks, unlike penguins and sheathbills, have no down when they hatch out of the egg but are featherless (altricial) for a short time.

## Port Lockroy

End of the landing. Fifteen minutes to last boat. Zip to Lockroy, world's southernmost post office. All women at the gift shop counter, all women at the base by design since (D tells me) scandal and suit. British. Logoed neck gaiters, fleece, hats. I'm urged to write myself a postcard. Don't. Rush the museum. Pemmican & Christmas pudding on shelves. Woolens, skis hung. A whole room in the cramped hut of six for machines that flout distance (telegram, etc). Jayne Mansfield painted behind bunkroom door, bombshell above each bunk. Not bad. Buy Antarctic tartan scarf with color key (white for ice, blue for ocean, yellow for . . .) Tourist. Help lug twined-up cardboard, boxes of glass, bags of cans to take aboard & away. Our part in how they manage.

snowy sheathbills
fed on boot-tracked gentoo shit
coo under porch grate

---

The base at Port Lockroy was established in 1944 to observe wartime enemy activities in and around the Peninsula. The British Antarctic Survey (BAS) operated the base as a science research station until 1962. In 1996 a small team of four carpenters spent two to three months restoring the base as much as possible to its 1962 condition and the base is now managed by the United Kingdom Antarctic Heritage Trust (UKAHT). Strangely (or not?), the main currency in the gift shop and post office is USD.

## On Another Ship, Elsewhere, in the Past

Not a ship but a craft. Runabout that, thirteen, I could run anywhere in the Sound (parents must have known my wanderlust fell well within their safe-sense). No radio. No cell phone. No EPIRB. Jarred, soft chop. Specific pound of that V-hull's fiberglass felt even now. Runabout. All in the name—not toward or away just *about*.

What I loved: cut engine, drift mid-channel, splay on deck belly to sky. Why, now, do I think of the boy I wanted to dress (and did) in deep plum sequin-chested V-neck gown formerly my mother's—then dance with? His name lost. His wide, freckled nose vivid. The coast I hugged to reach a public dock he walked to, too.

adrift, our bodies clouds
new shore sharpening into view from haze

---

An EPIRB (pronounced "ee-purb") is an Emergency Position-Indicating Beacon, a standard piece of safety equipment on most commercial boats and many recreational vessels. When dunked into 1–4 m of water, it automatically detaches, floats to the surface, and begins sending out a location signal. EPRIBs didn't exist when I was a kid in the early 1980s. Nor, of course, did cell phones (well, not ones a kid could carry around). I am still amazed by the trust my parents had in me.

# Marian Grotto

Been before but never noticed—snowed over? forbidden proximity?—arch
of flat stones stacked over black-painted wood frame which windows what
ghost? Steer closer, peer. Don't interrupt family chattering their moment
(The bright sky! Who lived here? I'd never. I would. Reminds me of . . .) Drift
& stare. A shape a form a woman behind the small window? Yes, *Ghost,* the
word spirits up. But no, Our Lady of Luján. Statue replicated, shadowed in
that snow-lashed, stone-lidded eye.

<div align="center">

what blue prayers
fogged against protective glass
have been offered, held?

</div>

Can't help it. Too beautiful. I interrupt, point, direct until the mother father
kids see her face glow through moist glint. What I wonder but don't share:
was she here when the shortening days were flame-lit, when a hot prayer to
*home* was made and taken?

<div align="center">

was that her?
what in that smoke was her prayer?

</div>

---

Our Lady of Luján is a sixteenth century icon of the Virgin Mary most known in Argentina. The Argentine base, Almirante Brown, was a year-round research station since it was built in 1964, but, in 1984, when told at the last minute that he would have to overwinter (despite an earlier understanding that he would not) the base doctor burned the station down so that he and the rest of the people there had to be evacuated. It is now a summer-only station.

# In Solution

ice-lidded or

fluid sheened veneer

depth with
/held

surging

# Paradise Harbor

—& it is. Peak-ringed, milk-clouded, a studded shimmer. Then flaw. Some other ecotour ship anchored. *Who?* Queries rise. *Who?* Shocked, curious, faced with a parallel yet unable to compare. Their Zodiacs cruise ice. Their people climb the hill above Base Brown we won't climb today. On the summit, someone with long, pink ribbons stuck to sticks cyclones them. *Who?* Steward in love with her own quirk? Stare. Sneer. Pine. This is Paradise. Argentine flags paint every roof. Claim in a land that sheds all claim. Malachite smear on cliff = profitable extraction potential. Copper carbonate hydroxide. Thus flagged despite Treaty & tradition. Focus on cliffside nesting blue-eyed shags. Precarious. Bowls basted to small ledges. Chicks nearly overspilling, huge compared to the just-hatched of Jougla. Not much about shags from explorers. Why?

<div align="center">

azurite eye

deeper, more keen than ice

aware, unwary

</div>

---

IAATO carefully orchestrates boats operating in Antarctica so that no two stop at the same spot at the same time. The goal is both to minimize impact and to maintain the illusion of solo-venturing. Malachite and azurite are both minerals produced by the weathering of copper ore deposits. Malachite $Cu_2CO_3(OH)_2$ results from the increased oxidation of azurite $Cu_3(CO_3)_2(OH)_2$, changing color from green to blue. The actual formula for the conversion includes the addition of a water molecule and the release of a carbon dioxide molecule.

## NEKO REDUX

A gift. This. Unfair to claim & there were others and yet this gift: a minke exhales, unseen but heard. Spot its dorsal sharp among ice, in calm-silk water. Then along and under (under) my boat, eye skyward. Sea-warbled but clear. Open. Met. Calm water. Flank gold with diatoms. Still. Chunks of ice. Enough time enough weather enough whale enough boats for all on ship to muster, seek, find and not crowd. To drift as it circles, approaches, finds us approachable, re-approached. All balance, all sense recalibrated.

<div align="center">

stretched on low ice
ignored in near distance
a leopard seal yawns

</div>

# LEMAIRE CHANNEL

We growl through Kodak Passage pancake. White, splintering ice. Peaks (Una's tits) peek through mist, blue glacial hum under dusting of snow. Help L lever open the watertight door, test deck for slick, open the bow.

Guests, staff, all throng. Low, exposed, somehow *closer*. Explore a ship-spot more often off limits. Relief to be along the unpretty work of it: cleats, greased cables, lashed anchors. No plush scrim over steel. T sticks his head down into the hawse, watches ice split against bow bulb. One by one, we all do. Shoulders wedged. Asses up. Austral ostriches.

Poor ice. Grind & crack. Yet this, more than *landscape*, may be the point. True? To push metal through frozen water. Pretend power in this place that rebuffed us (which, too, delights) last trip with wind & thick, rafted pack. Rounds of people bundle out. Thrill. Tire. Chill. Retreat. Return.

in fog-blurred distance
a mast, splinter-thin, disappears
we wager their fate, ours

---

The hawse is the hole through which the anchor chain passes.

# First

Calm, so we stop at Charcot. No one aboard's been, but there are rookeries, stories, views, so why not see. Been on how long now? Six weeks? Seven? Low light. Red coats march uphill. My orange stationed alone at the flagged path's foot. Unsure of what I've traveled, seen, perhaps earned. But now the moment: most forbidden & natural act of my time here.

> fumble toward new-gaped cold
> squat, sigh pishing into snow
> a Weddell seal snores

Home, the certificate in a box with others: birth, sixth grade graduation, love letters proven false, Arctic Circle, this (first piss).

---

When applying for a National Science Foundation grant for the Antarctic Artists and Writers Program, I learned that if I were to camp out on the ice, I'd not only have to bring back all solid waste, but all liquid waste as well. "Pishing" is a nod to Bashō who describes, in poem 31 of *Back Roads to Far Towns*, the horse urinating by his pillow. In the 1968 Grossman Publishers translation by Cid Corman and Kamaike Susumu, this action is rendered as "pishing."

# IDENTITY POLITICS II

Weird vibe. Not sure why/what but tension belowdecks. Whatever. Grab food, grab binos, go up and scout for what might be unexpected thus worth shipwide attention. Blue petrels! Eye finally calibrated to catch white tail band among prions. R wanders over with news. One guy *caught* with crew-mate.

<div align="center">

months-fed hunger
away, at sea, adrift, fluid

</div>

So, confirmed: what's fine for guests is not for crew. How to figure which of the two (clearly one) is seen in the wrong? I can guess which: whoever's closer to *faggot*. Fuck. Replay snubs I've felt. Cringe at my past play-alongs of flirt that didn't stop & insist on my desire's key truth: *Not you*. They can't not know (homelife pronouns clear) yet I've passed. Chin-length hair, dresses on nights it's expected. So, defiant, I stride whistling to stern. M cringes then laughs when she sees it's me: I'm allowed. *Only bo's'ns and queers.* The tuneful, storied bad beckoning for wind & the melody of my redeemed, re-claimed, flaunted permission.

---

Sailors are a superstitious lot. Of their many beliefs is that whistling on a boat will "whistle up the wind," which is not good. Only bo's'ns (who once sent commands via a whistle à la Captain von Trapp) and queers (which no historic sailor would claim as an identity) are allowed to whistle aboard a boat. I admit it, I take perverse delight in my right to whistle.

# Baily Head: One Macaroni

Suss the steep hissed beach from wheelhouse. Possible? Impossible? White surf & black rock ground to lentils. Swap stories on the bridge. Obvious possible & remembered disasters: Breakers over hunched passengers, lenses chest-clutched. Boat flipped, water a flail of life jackets (salt tabs dissolved & gassing full). Sailor's chest waders topped & turned anchor until grabbed and hauled up.

Decide to land. Prep to hit shore invasion-style: roll out, run up. Crew first. Tamped bravado thrill. Ban the unsteady & slow. Make of ourselves a tow rope: grab & pull upbeach next to next. Chinstraps waddle-dash downbeach out into breakers five, ten at a time, off to forage. Chinstraps surf in, porpoising up for nest changeout, chick feed, rest. Low fog. Sheer basalt. Monochrome world. Then

among utilitarian hordes
dandy crown, coral beak
unreplicated

---

Macaroni penguins have brighter, wilder plumage than the Adélies, gentoos, chinstraps, emperors, and king penguins that one can see on the Antarctic continent. Although they are the most numerous penguin worldwide, for travelers to Antarctica, spotting one can be a challenge. "Dandy" references the origin of the Macaroni's name: Maccaronism was a term for a particular style in eighteenth-century England marked by flamboyant or excessive ornamentation. A person who adopted this fashion was labeled a maccaroni or macaroni, as in the song "Yankee Doodle."

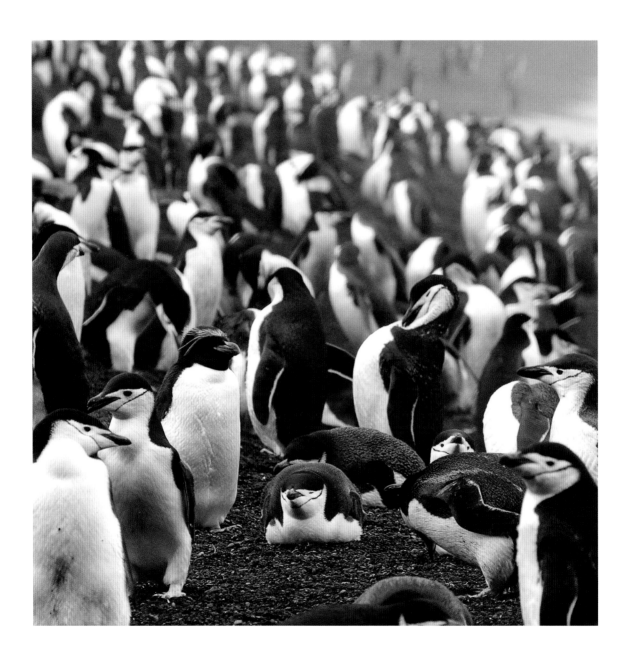

## WHALERS BAY, DECEPTION ISLAND

To be here means we're on the way out. Most staff think it's a bummer of a last stop. I like it. In through the caldera's gap. Flurries of rain, snow, cape petrels flirting their nests. Gloomy. Lithographic. Bay of ashen sea ice, black sand shore steaming with unfinished heat. Rusted collapsings, greened moss under gull nests, mineral oxblood hillside cascade.

<div align="center">

tired volcano
shelter for ship and slaughter
fog seethes *history*

</div>

Prep benches, towels & cheer (life ring ready) guests who dash-plunge the steamed sea. Didn't join until my last time, then high-stepped it once most were gone. H likes to wait until everyone else leaves, then sneak into an outbuilding & scream.

---

Ships coming in to the nearly entirely protected harbor of Whalers Bay, an active volcano, must remember stories of the last eruption—just a few decades ago. It smolders still. However, on the right tide and day, it can also make the water a little nicer for a polar plunge.

# IV.

## HEADING HOME

# Repair

Bracelet I've worn since I took it from you, now broken. Two places. (each of us? our separate journeys here? these months apart?) No warning. Sudden snag pulling layer & layer on.

<div align="center">

flaw in a dream of this place
now I've come

</div>

If guys in the metal shop can make propellers from scrap, they can fix this. Chief engineer returns it. Unfixed. *Too pretty. Too nice. Afraid they'll damage.*

<div align="center">

thing of shine, thing of shimmer
worn through our wearing

</div>

I want them to mar it. Want it worked below decks within walls of metal, deck of metal, overhead, hull, & all metal making us possible here. Mar story. Storymar. Repaired as we left. Pounded whole as we pounded north. Home. Look. Fixed.

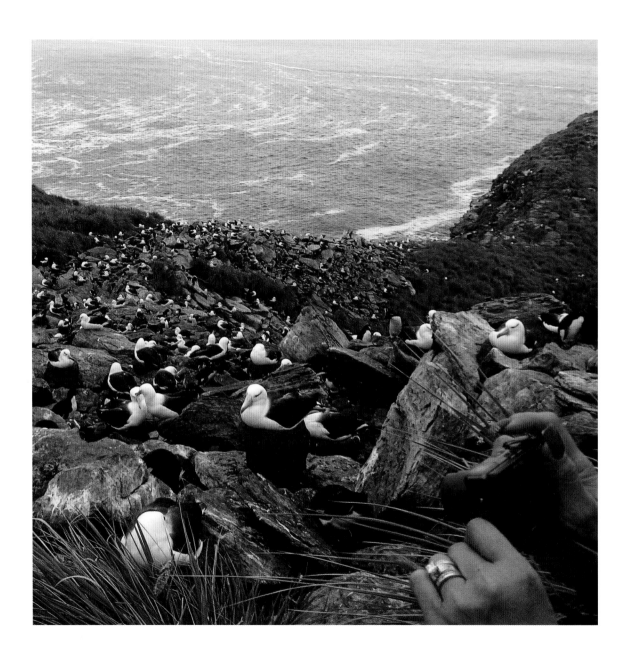

# Beagle Channel

A term, *green blink*, for seeing trees again. Doubt we've earned it yet we're shocked. Walk to fantail. Walk to bow. Hide as the departing pack. Avoid their nostalgia, the tended & nurtured lack for which they prepare. *We were there, we were there, we were . . .* Magellanic penguins swim abeam. *Nothofagus* twist & lean. Channel a shaded lane to trip's end. If we (secret goal) hit port in time & clear customs, staff dinner in town.

Our ship tied alongside another ship that did the same thing on a different route. Theme & variation. Both moored astern of a trawler. Forklifts & delivery trucks track the pier. Argentina. A country. Cuisine, license plates. Beside port security, a sign telling how the British stole the Maldives. Placard of resentment & preparation.

<div align="center">

even the highest peaks green
with temperate concerns

</div>

---

For a wonderful resource of Antarctic terms, try Bernadette Hince's *Antarctic Dictionary.* The long-standing feud between Argentina and England that flared into the Falkland Islands War in the 1980s smolders still and might reignite over oil drilling right off the Falklands/Maldives. The port sign, seen in 2011 and 2016, read: "We inform our visitors that by the Argentine National Law No 26.552, the Malvinas, South Georgias, South Sandwich Islands and the surrounding maritime areas as well as the Argentine Antarctic Territory, have been included in the jurisdiction of the Province of Tierra del Fuego. At the same time we should remember that the Malvinas, South Georgias, South Sandwich Islands, and the surrounding maritime areas are, since 1833, under the illegal occupation of the United Kingdom of Great Britain and Northern Ireland."

## Sightings Log: What Has Come to Seem Common

Black-browed albatross, Cape petrel, gentoo penguin, giant petrel, Antarctic fur seal, brown skua, kelp gull, Wilson's storm petrel, chinstrap. Kings on South Georgia and the Falklands. Crabeater (not leopard, though they claim more memory than viewings warrant), Antarctic tern, blue-eyed shag. Wind. Ice. Not humpbacks (though seen), not minkes (even despite), not (alas) orcas or blues or southern rights. Never enough prions. Snow petrel, that winged angel telling old sailors of shore. Snowy sheathbill.

my envisioned cairns
Shackleton, Scott, Amundsen
surprising lacunae

# Five-Year Checkup, 2017

*Is it different? Do you notice? Do you see?* Less ice. Warming's burden. Really they're asking, *Have I missed it?* I don't know. Less snow this season. More humpbacks maybe because less ice and thus the minkes elsewhere. More fur seals and, thanks to fewer rats, more pipits. Gentoos nudging Adélies out. This year: a worrisome slurry of salps at Paradise, Point Wild, & Deception. We gawk at tabular bergs, awed, unsure if it's ok to find them beautiful. The big picture? We chug along. I'm no gauge, my stick too short to measure true. But I've seen the colorful maps. Why do you need me to say it? It's red where we sail. I don't know if our presence is benign.

---

As temperatures rise in the Antarctic, gentoo penguins have expanded their range while Adélies have declined in many areas. Salps in the Southern Ocean, specifically *Salpa thompsoni*, have attracted the attention of climate change scientists. Recently, they have been increasing in numbers, while krill have been decreasing. This is of concern because it indicates a potential regime shift, and because salps have much less nutritional value than krill, which power the Antarctic food web.

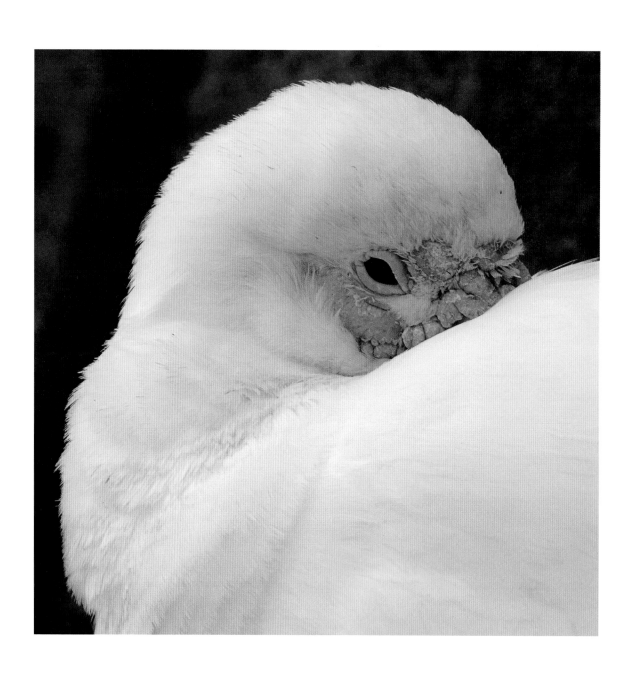

# HOME

dog resentful    bed other-warmed

   shocked anew

  by the ambition of trees

# Point Wild Coda

Four and a half months home & now this photo emailed from there: the crew (minus me) hugging Pardo's bronze shoulders. Fuckers. Ashore. Chinstrap chicks nearly tall as adults. No date for *when taken*. Would I have liked this as my story?

> For once seas calm, we land. Get everyone ashore & off again. Then, passengers aboard, all Zodiacs lifted but one, we clamber & grin by the pilot we'd pointed to & talked about & never . . .

Gaps of yearning. Gaps of time. I'm okay with being disallowed by weather. Snuggery of the overturned boat gone anyway. Glacier surging & calving its revisions to this place. Look at them, my shipmates, without me: bright gear, polarized glasses, radios. Well-fed. The season's little resentments & rivalries dim. Nice teeth. Nice teeth. Maybe next time I'll get to feel the disappointment of the actual. Until then—

---

Luis Pardo was captain of the tug which rescued members of Ernest Shackleton's party from nearby Point Wild in August 1916.

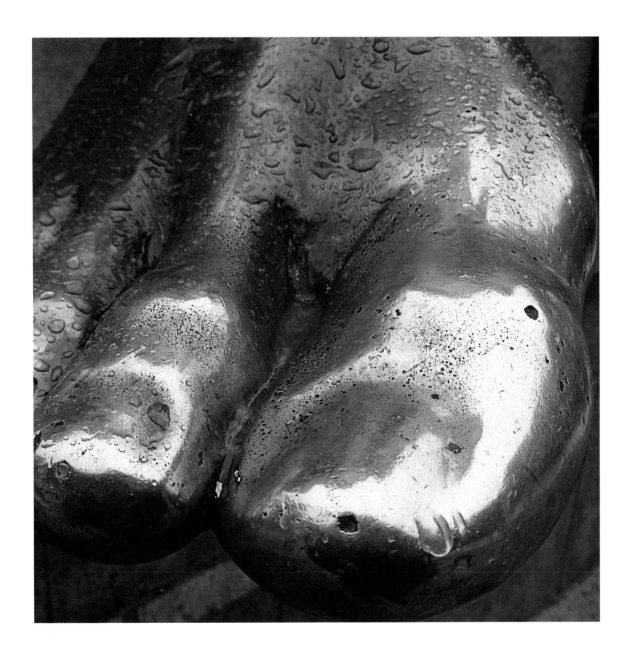

# Epilogue: A Letter Home

January 8, 2017

Dear America,

A wandering albatross just soared by my porthole. I am in the Southern Ocean, traveling between Antarctica and South America.

Before the bird startled me, I was reading Thies Matzen and Kicki Ericson's beautiful book about the two years they spent on South Georgia Island, moving from bay to bay in their small wooden sailboat.

Small wooden sailboat. In bays and fjords that freeze over in winter, in the long dark of howling weather, along a coast with no backup plan. No bluster to their stories. No swagger or machismo. From 2009 to 2011 they were surprised and humbled and charmed and terrified by penguins and glaciers and leopard seals and storms and solitude. For them, the vast, raw place was made of intimate moments. Tenderness, even. America, I want all of us to know wild places in this way.

I've spent the last month working as a naturalist on a ship that spends the austral summer taking tourists to the Antarctic. When I joined the expedition, we left Ushuaia, at the tip of South America, crossed the Drake, prowled a few bays and shores of the Antarctic Peninsula on foot and by Zodiac, returned, headed east toward the Falkland Islands and South Georgia, sailed southwest to the Peninsula again, and are now heading north.

The boat will do variations of this route all season, carrying visitors from America, Australia, China, India, Europe, and elsewhere, all of whom have found a way to get here, to this longed-for, difficult, leaderless continent set aside in 1959 "for peaceful purposes only" as a space for "scientific investigation . . . and cooperation toward that end."

In their epilogue, Thies and Kicki write about the phenomenal recovery of South Georgia after industrial whaling sputtered and the island was abandoned by people. Tussac grass returned to trompled hillsides. Skies cleared of blubber-smoke. Fur seals rebounded from near extinction.

Solitude was part of the balm. But so was the hard work of people who began to pull back the harm done: introduced rats and reindeer, asbestos in the ruining buildings. The restoration of that place is working and it is not working. Certain things are healing, but other harms encroach. America, recovery is more complicated and more simple than we know.

At home on Cape Cod, I have been tracking the decades-long recovery of the gray seal population. Some think their return is not restoration but ruination of what we came to know in their absence. Some want to start killing them again. I don't agree, but I'm interested in the different places our understandings come from. Where do we source our information and how do we scrape down to the truth? How are we going to agree and make a plan to move forward, America, on this one subject in our own crowded, conflicted, contradictory, not-wholly-known land? There are so many subjects about which we are asking these questions.

In Antarctica, the ocean today feels the same as it did five years ago, the last time I worked in these waters. The same birds soar above the waves, tipping their wings. My wonder is greater upon returning. My knowledge of the threats they face: greater too.

America, some of you have asked, but I can't say that I see the effects of climate change here firsthand. There are differences, but are they moments or trends? I started looking too late. I haven't looked long enough. But that doesn't mean I don't believe the scientific papers about warming oceans, rising seas, acidification, changing weather. It doesn't mean I don't fear the consequences.

Now I am headed home. Back to grocery shopping and teaching and bills. Back to neighbors and their conflicting political yard signs. I've been keeping up with the news in small doses. I've been plotting my course.

Thies and Kicki navigated to South Georgia from the Falklands without a GPS or sat phone, a distance of over 1,500 kilometers. They brought books and apples. They were cautious and experienced. Time slowed for them. We also need time to plan wisely, to wait out storms, to take a broad view and allow contradictions to have their space.

Was it an escape to come to the cold, hard edge of the world? Did I flee? Did Thies and Kicki? Maybe, but I have to believe that we return to our homes changed and strengthened. Better able to make new connections and see from new perspectives. Maybe even better at slowing time.

America, how do we care for what is far from us as well as what is near? How do we acknowledge the legacy of a plastic-wrapped sandwich or throwaway keychain? How do we account for the hidden costs of our phones, tablets, laptops? I embody so many of our modern, American contradictions: my environmentalism and my 120-mile commute, my certainty that wild spaces are necessary and my chugging toward them in a diesel-powered boat, my love of diverse community and my home in a largely white township.

On this ship, among the crew, Americans are in the minority. As a crew we are Filipino, Indian, South African, Bulgarian, Austrian, Chinese, New Zealander, Latvian, Irish, Columbian, and more. There are fissures between us. Bigotries. But also a sense of the interdependence we share aboard the ship.

But then, one fragile hull holds us all, doesn't it, America?

Thies Matzen and Kicki Ericson, *Antarktische Wildnis: Südgeorgien* (Hamburg: Mare Verlag GmbH, 2014), ISBN 978-3-86648-246-3. (In German, with an inset of selections translated into Chinese and English.)

# List of Images

# INFORMATION AND ACTION: GET ENGAGED

There are many admirable organizations involved in both protecting and understanding Antarctica and its ecosystems. If you'd like to learn more or support conservation efforts, this short list is a beginning. Even things you do at home to prevent plastic pollution and carbon emissions can make a difference in Antarctica. Take action by either supporting or participating in one (or more) of these organizations. They are not listed in order of priority.

Agreement on the Conservation of Albatrosses and Petrels—acap.aq

> Thirteen countries have come together to protect sea birds. Excellent educational resources on their website.

Antarctic and Southern Ocean Coalition—asoc.org

> Over thirty NGOs come together here to work for conservation in Antarctica. Their marine protected area program (spearheaded by the Antarctic Ocean Alliance) and their work to measure and mitigate human impacts on Antarctica are particularly notable.

Bird Life International—birdlife.org

> Leading the campaign to reduce seabird bycatch, such as albatross caught in longline fisheries, BLI also is home to the Global Seabird Tracking Database.

Commission for the Conservation of Antarctic Marine Living Resources—ccamlr.org

> Although part of the Antarctic Treaty Organization, this branch is worth mentioning because of the work it does to advance marine protected areas. It was founded after increasing interest in the Southern Ocean's krill fishery.

Happywhale—happywhale.com

> Through Happywhale, visitors to Antarctica can help build the sightings database for humpbacks and other species of whales. Submit photos, location, and time to put a data point on the map.

International Association of Antarctica Tour Operators (IAATO)—iaato.org

> Rich resource of information about Antarctica and also how to responsibly visit the continent, including member companies, wildlife watching guidelines, and more.

Plastic Pollution Coalition—plasticpollutioncoalition.org

> This global alliance takes on the growing and toxic problem of plastics. Local and international groups provide places to get involved.

Polar Citizen Science Collective—polarcollective.org

> A portal for various projects that visitors to Antarctica can participate in by contributing sightings data and other information. Leopard seals, clouds, penguins, ice, and more.

Seafood Watch—seafoodwatch.org

> Overfishing is a global problem, but by being informed about what's on your plate you can make good choices. There are many marine stewardship organizations that provide lists of sustainable fisheries, but Monterey Bay Aquarium's Seafood Watch app is a good place to start.

Secretariat of the Antarctic Treaty—ats.aq

> The Treaty is the foundation of all work on and in Antarctica. Every interested person and visitor should be aware of its scope, power, and efforts. It comes up for ratification on a regular basis, and your vigilance in keeping it strong is necessary as pressure increases to "use" the resources in Antarctica.